EGON SCHIELE

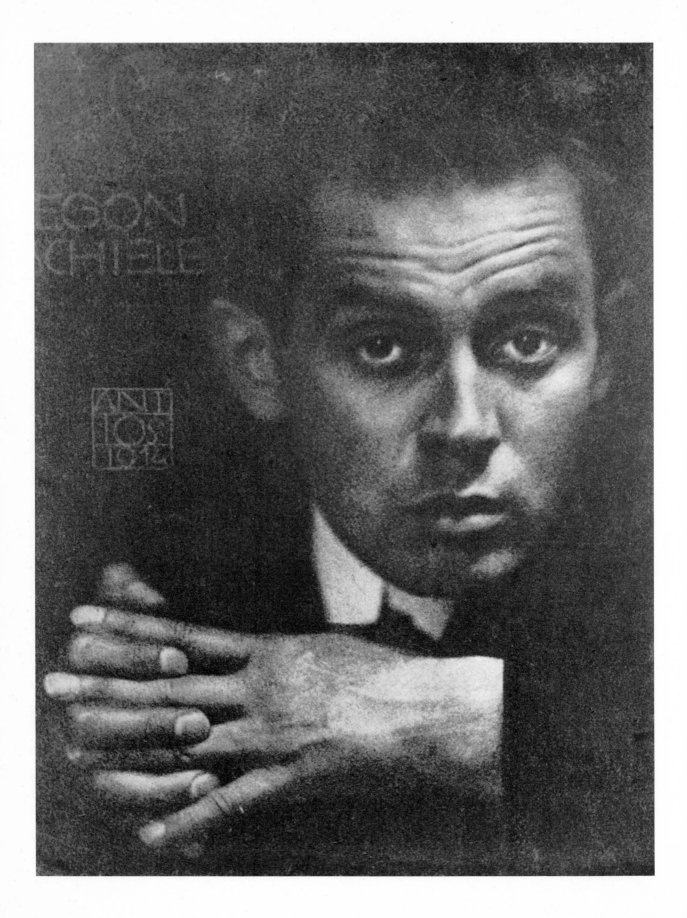

Alessandra Comini

EGON
SCHIELE

THAMES AND HUDSON
LONDON

For Isabelle and Lili

First published in the UK in 1976 by
Thames and Hudson Ltd, London

Printed and bound in West Germany

ACKNOWLEDGMENTS

I am especially grateful to Dr. Otto Kallir, whose two Schiele oeuvre catalogues (1930; revised 2nd edition, 1966) form the basis upon which any study of Egon Schiele must build. The notation "K." followed by a number indicates the Kallir oeuvre numbering in the second edition of his catalogue. My debt to the Schiele heirs is enormous: most of the photographic material reproduced here was supplied by Gertrud Peschka-Schiele and her son Anton Peschka, Jr., and by Norbert Gradisch, custodian of the late Melanie Schuster-Schiele estate. I am also thankful to Walter Koschatzky, director of the Graphische Sammlung Albertina, to Hans Aurenhammer, director of the Österreichische Galerie, to Franz Glück, former director of the Historisches Museum der Stadt Wien, and to numerous private collectors in Europe and America for their generous cooperation.

Thanks in particular are due to Viktor Fogarassy of Graz who made available such a large selection of the Schiele works in his collection. Color photography was done by Foto, Marco, Graz.

Thanks and admiration go to the enlightened publisher, George Braziller, for the idea of this book and to Julianne J. deVere for the production.

The tactful and tenacious editorial criticism responsible for the readability of the text was provided by Julianne J. deVere in New York and Megan Laird Comini in Dallas.

Cover design by Raiberto Comini and Mike Firpo; layout of visual material by the author; book design by Mike Firpo.

Frontispiece: Egon Schiele in 1914. (Photograph by Anton Josef Trčka, Vienna.)

CONTENTS

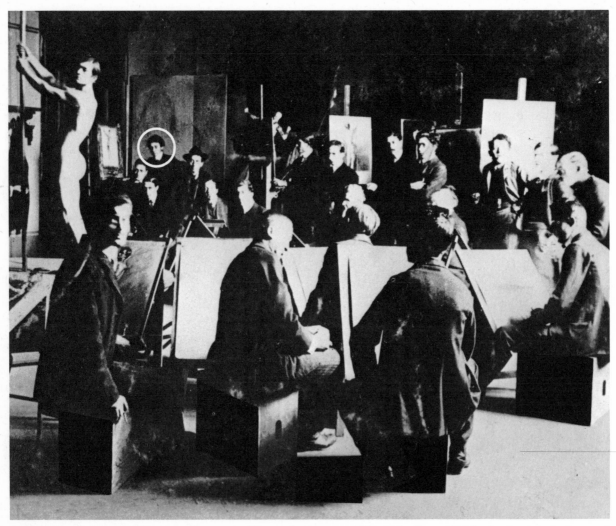

1. Photograph of the Life-Drawing Class at the Vienna Academy, c. 1907, with Egon Schiele in far left background.

If objects could speak, the dignified history of the Vienna Academy of Fine Arts might best be told by the simple wooden seats in its classrooms. A familiar art school sight, these crates—more rectangular than square, with hand grips cut into their sides—served from the 1720s as stools for students who enrolled at the Academy (Fig. 1). They were still in use 180 years later (Fig. 2), and, perhaps somewhat more slippery for wear, continued to provide a sturdy rear guard for young artists as late as the 1940s (Fig. 3).[1] Such perpetuation suggests academic continuity, of course, but also hints darkly at an even more obdurate resistance to change. Indeed this was the charge twice hurled at the Academy by its own students: once in 1809, by the future Nazarene artists Friedrich Overbeck and Franz Pforr, and again in 1909, exactly one hundred years later, by the future Expressionist artists Anton Faistauer and Egon Schiele (Fig. 6). Although the names of the professors had changed, the boxes and the "myopic" curriculum had not. The complaint of 1909 was that of 1809: the aims and methods of the Academy were hopelessly mired in the classical quicksand of Winckelmann's dictum that "It is easier to discover the beauty of Greek statues than the beauty of nature."

Both the Nazarenes, who found fulfillment as "German Romans" in Italy, and the Expressionists, who for the most part remained at their battle posts in Vienna, yearned for a revitalization of art, which, through awareness of *contemporary* concerns, would shake off all foreign accents and emerge as an original, spiritual, and national expression. The urgent sense of purpose that characterized both groups can be sensed in their self-portraits (Figs. 4 and 5): the Nazarene Victor Emil Janssen (1807–1845) and the Expressionist Egon Schiele (1890–1918) gaze at and record the phenomenon of their exposed bodies with unflinching earnestness. It was not just the boxes, but an almost fanatical solemnity that linked across a century these young representatives of two anti-Academy movements.

Who was Egon Schiele, that he, an unknown nineteen-year-old Academy student (Pl. 81b), coming from an unimportant small town and a conventional family, could become within four short years after his arrival in Vienna one of the major exponents of Expressionism? Why did he become a leader in the rebellion? His cause was escape from oppression, from the narrowness and restrictions of a conformist family and society. He had hoped to find freedom to express himself at the Academy, and yet even in that chapel of art, it was as though he walked daily through a door over which hung the inscription: "Thou shalt not."

During the century between the Nazarenes and Expressionism in Vienna, the anachronistic—"Thou shalt not"—curriculum of the Academy had not gone unchallenged. Ferdinand Georg Waldmüller (1793–1865) had published in the 1840's two severe critiques of the school's lack of response to contemporary trends in art. Austria's greatest landscape painter, he had power-

2. Martin Ferdinand Quadal, *The Life-Drawing Class at the Vienna Academy,* 1787. Oil. (From E. Pirchan, *Künstlerbrevier,* Vienna, 1939.)

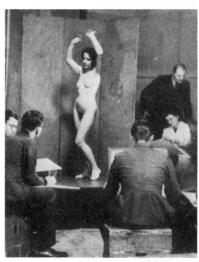

3. Photograph of the Life-Drawing Class at the Vienna Academy, 1940. (From *Kunst ins Volk,* Vienna, 1940.)

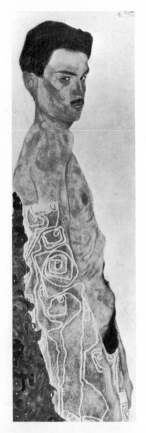

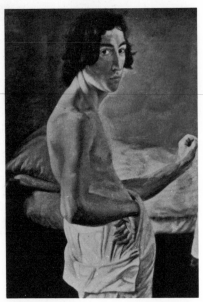

4. Schiele, *Self-Portrait Nude,* 1909.
5. Victor Emil Janssen, *Self-Portrait,* c. 1828. Oil. Kunsthalle, Hamburg.

lessly watched the Academy abolish its landscape-drawing class in favor of more "copying from the antique"—specifically from the 1,650 plaster casts of classical statues in the school's collection. Waldmüller's eloquent and inflammatory demands for reform were republished in 1907, and by that time the second-year Academy student, Egon Schiele, whom we can spot standing morosely in the background of his life-drawing class (Fig. 1), was ready to agree that the so-called humanistic tradition of the Academy was inhumane. This sentiment was aggravated by the presence of Professor Christian Griepenkerl (Fig. 7), director of the School of General Painting. Griepenkerl epitomized the backward-looking "eyes-on-Rome" policy of the Vienna Academy as it entered the twentieth century. The gifted Expressionist artist Richard Gerstl (1883–1908) studied for two tortured semesters under Griepenkerl in 1904. When the unhappy Gerstl commited suicide four years later, the aging professor interpreted it as a willful defamation of *his* Academy! Griepenkerl was obviously not prepared to tolerate signs of secession.

And yet Secession with a capital S was just what the Academy was now combatting, literally in its own back yard. Josef Olbrich's daring new exhibition hall, built to house the shows of the Vienna Secession Group—led by Austria's leading Art nouveau painter, Gustav Klimt (1862–1918)—had recently presumed to raise its "cabbage" cupola just one-half block from the back door of the Academy. Displacement of classical antiquity by the "effrontery" of modern art was visualized in a satiric depiction (Fig. 8) by Klimt's colleague in Munich, Franz Stuck (1863–1928). This was interpreted by the Vienna Academy professors as a real threat in their city, with that pest-hole of a Secession building flaunting its pernicious contents in the face of every Academy-bound innocent. In vain did the Academy enjoin its students to copy works from the Imperial Collection, housed in the nearby new Kunsthistorisches Museum; too powerful was the siren call of the Secession exhibits, with their handsome, uncluttered installations and high-voltage "modern" content. The professors' fears were realized: Academy students such as Schiele were sketching and paraphrasing not the works of Raphael but those of Klimt (Figs. 9, 32 and Pls. 50a, 50b). Gustav Klimt— anathema to academia[2]—was an independent articulator of art's avant-garde, and a reticent, private man who ultimately rejected public life in favor of the isolation of his secluded, unkempt garden where, dressed in the loose-flowing robes of a monk, he could contemplate the, to him, omnipresent sensuality of nature (Figs. 50, 58).

But not even Klimt's glorious icons, horrific and titillating as they were, could long satisfy the new century's expositors. For Gerstl, Schiele, and some of their sober-minded Academy colleagues, Klimt was too intimately bound up with the spectacular art of the facade, drenched with the Dionysian pseudo-

classicism of Richard Strauss and Hugo von Hofmannsthal, whose predatory Clytemnestra so uncannily parallels Klimt's compelling femmes fatales. Their theatrical images held but a tenuous place in contrast to the reality of poverty and social distress in so much of pre-World War I Vienna. A century before, the Nazarenes had flocked to Italy to depict the unspoiled classical beauty of simple peasant girls, but now Schiele, Kokoschka, and other budding Expressionists portrayed the homeless street urchins (Pls. 5, 54) of their own country, challenging the social conscience of their age. Under such conditions things had to come to a head at the Academy. In the year 1909, exactly a century after the formation of the Nazarene Brotherhood and for almost the same reasons, the Vienna Academy again witnessed a secession of some of its most talented pupils. A group from Griepenkerl's drawing class, led by Schiele, and including his future brother-in-law Anton Peschka and Anton Faistauer, drew up a thirteen-point demand for reform, so drastic that the students' dismissal was avoided only by their prompt resignation. Waldmüller's indignation and the Nazarene longing for a rejuvenated national art were once again eloquently voiced. The Viennese Expressionists left the Academy to form a *Neukunstgruppe* (New Art Group) which took upon itself the bold task of penetrating the symbol-laden veils of Klimt's sumptuous facades to expose a frightening and provocative phenomenon lying just beneath.

And what was it that lay hidden yet pulsating behind the glimmering facades of Klimt's beautiful landscapes, allegories, and portraits? A cosmos—the vastness and the intimacy of which the new science of psychology had only begun to chart. This cosmos seemed to encompass a collective and an individual psyche. It was no longer the soul, with its religious connotations, but rather the psyche that appeared to be the motivating force for and the repository of human history. The overwhelming fact of pure existence took center stage at the beginning of the twentieth century, and the increasing evidence supplied by writers, philosophers, and artists indicated that the fact of being was posited within a void. This strongly felt sense of the nil caused the pervading angst so characteristic of the decade just before the outbreak of World War I. Klimt's plenum was in reality a horror vacui, and the younger generation's rejection of the facade meant an extraordinary confrontation—an extreme attempt to plumb and explain the void in terms of the psyche. Hence the tremendous seriousness evident in the three genres of Expressionist painting: portraiture, allegory, and landscape.

A new receptivity to pathos explains the marked affinity of the three great but dissimilar exponents of Viennese Expressionism, Gerstl, Kokoschka, and Schiele. The oldest of the triumvirate, Gerstl, had already disowned not only the Academy but also the "old-fashioned" works of Klimt by 1907 when he painted the hauntingly disturbed image of himself, sardonically entitled

6. Egon Schiele, the Academy student, in 1908.

7. Professor Christian Griepenkerl (1839–1916), director of the School of General Painting at the Vienna Academy.

8. Franz Stuck, "Sweeping Out the Glass Palace," c. 1888. Ink. (From A. Sailer, *Franz Stuck,* Munich, 1969.)

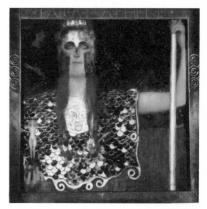

9. Gustav Klimt, *Pallas Athene,* 1898. Oil. Historisches Museum der Stadt Wien, Vienna.

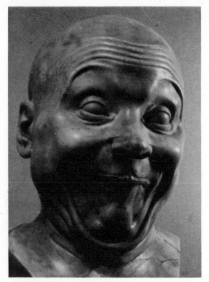

10. Franz Xaver Messerschmidt, *Self-Portrait Grimacing*, c. 1780. Polished marble. Österreichische Galerie, Vienna.

11. Richard Gerstl (1883–1908). (Photograph from O. Kallir, *Mitteilungen der Österreichischen Galerie*, Vienna, 1973.)

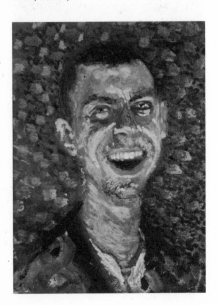

12. Richard Gerstl, *Self-Portrait Laughing,* 1907. Oil. Österreichische Galerie, Vienna.

Self-Portrait Laughing (Fig. 9). The lower portions of the face—throat, chin, mouth, and cheeks—are starkly illuminated from below, a time-honored device calculated to emphasize the "bestial" aspects of the flesh rather than the reasoning qualities of the intellect.[3] A crisis in Gerstl's personal life—the rejection of his declaration of love to Arnold Schönberg's wife Mathilde—caused the suicidal hysteria documented in this remarkable autoscopy. He concentrated on recording what happened to his "facade" (Fig. 11) as inner feelings were registered upon it. This quasi-scientific scrutiny of external appearances under emotional stress had a precedent in the fifty-four grimacing life-size self-portrait busts (Fig. 10) by the eighteenth-century recluse and former professor of sculpture at the Vienna Academy, Franz Xaver Messerschmidt (1736–1784). Gerstl's psychogenic self-study also benefited from the intervening century's sensitivity to the neurotic, as developed in Austrian portraiture by Anton Romako (1834–1898) and Gustav Klimt (Fig. 17). Gerstl, in his close-focus concentration on self devoid of environment, is like Van Gogh and Munch, two fellow geographers in the terrain of the human psyche.

A new and brutal realism, born not of objective verisimilitude but of subjective "truth," was the exploratory tool of Viennese Expressionist portraiture. The pathos given by Oskar Kokoschka (b. 1886), next oldest member of the Viennese triumvirate, to the derelict appearance of Vienna's beloved café poet Peter Altenberg (1859–1919—Figs. 13, 14) demonstrates the visionary force of Expressionism. Kokoschka's arresting portrait icon of the benevolent bohemian, himself one of the rootless persons described in his own trenchant chronicles of the passing scene,[4] suggests not the absent-mindedness of a drunken poet but rather that of a person gripped by inspiration. The dignity accorded Altenberg removes the image from the facile realm of caricature to which the poet's bumbling appearance frequently relegated him (Fig. 15).

Why was Egon Schiele, the youngest triumvir, also drawn to his own brand of pathetic, or "pathological"—as it was labeled—portraiture? What were the elements in his upbringing and personality that encouraged him to become, like Freud, a self-conscious assailant of the Viennese facade, selecting as his special goal exposure of his society's hypocritical and repressive attitude towards sex? A specific factor influencing the artist's life-long obsession with sexuality was that his childhood years had been overshadowed by the recurrent illness and advancing syphilitic insanity of his father. Adolf Schiele, stationmaster of the provincial railroad station at Tulln (Pl. 73b), was eleven years older than the girl, Marie Soukup, with whom he posed for their engagement photograph (Pl. 73a). The sixteen-year-old bride, marrying against her family's wishes, aged rapidly under the burden of the infection bestowed upon her by a husband who refused to be treated for his disease. Her first three children, all

boys, were stillborn. A girl, Elvira, lived only ten years (Pls. 74a, 76a), and a second girl, Melanie, born in 1886, was the first to escape the grim family heritage, living to be almost ninety (Pls. 73b, 74a, 76a, 76b, 77b, 82a, 82b, and 84c). On 12 June 1890 Egon was born (Pls. 74a, 74b), and a final girl, Gertrud (known as "Gerti"), arrived four years later (Pls. 76b, 77b, 77c, 83a, 83b, and 84b).[5] The prematurely worn mother, with her son and daughters and ailing husband, lived over the Tulln railroad station (Pl. 73b), where the little boy could see and draw the passing trains (Pl. 75b). One of the rare smiles to illuminate the child's serious features (his later self-portraits and photographs are without exception deadly earnest) was captured in a photograph of Egon holding his toy locomotive (Pl. 75a). Otherwise Egon had little reason to smile.

The family's fortunes ebbed and in 1902 they moved from Tulln to Klosterneuburg, an attractive old abbey town not far from Vienna. Melanie went to work as a cashier in the railroad station and Egon attended the abbey school where his extraordinary drawing talent received recognition and encouragement from the local art teacher. Soon his family accepted him as a *Wunderkind*. But the handsome father, who had once proudly sat for a photograph of himself with his small son on his lap (Pl. 74c), was now deteriorating into a sometimes violent invalid, who once in irritation set fire to all of Egon's carefully executed railroad car drawings. This was not to be the only time that Schiele's work would be deliberately burned. The last photograph of Adolf, taken with Schiele's younger sister Gerti (Pl. 77c), shows a pathetic husk of a human being. Adolf died completely insane on the last day of 1904. The death was not declared until the following day, so the family might qualify for a larger pension. A truculent Egon was made the ward of his aunt's husband, Leopold Czihaczek (Pls. 80a, 80b), an inspector at the North Railroad Station in Vienna.

The impact of his father's tragedy on the fourteen-year-old Schiele was incalculable. Almost as though in retaliation for the venereal origin of the disease that had shadowed his family, the boy threw himself into a stormy adolescence of sexual exploration and activity. He learned not only the secrets of his own body, but also those of Gerti's. When he was sixteen and she twelve, they repeated their parents' honeymoon trip to Trieste, spending the night in a hotel.

The resolute young face that stares out at the beholder in the *Self-Portrait* of 22 September 1906 (Pl. 51) belonged to a strong-willed individual. At sixteen Schiele was precocious in several ways: in his sexual sophistication, in his undeniably remarkable gift for drawing, and in his determination to become an artist. To this end he eloquently persuaded his mother, in the face of spirited opposition from bourgeois Uncle Czihaczek, to allow him to study art in Vienna. His talent accomplished the rest. Professors

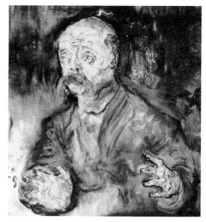

13. Oskar Kokoschka, *Peter Altenberg*, 1909. Oil. Private collection, U.S.A.

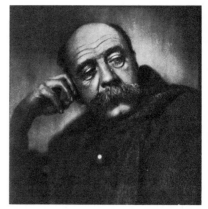

14. Peter Altenberg (1859–1919). (Photograph from a contemporary postcard.)

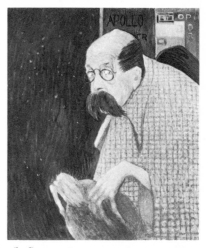

15. Gustav Jagerspacher, *Peter Altenberg*, 1907. Oil. Formerly in the Adolf Loos "American Bar," Vienna.

11

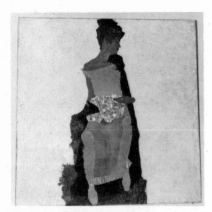

16. Schiele, *Gerti Schiele*, 1909.

17. Gustav Klimt, *Fritza Riedler*, 1906. Oil. Österreichische Galerie, Vienna.

18. Eleanora Duse (1859–1924). (Photograph from B. Segantini, *Eleanora Duse*, Berlin. 1926.)

who saw his work advised him not to study at the Kunstgewerbeschule (the School of Applied Arts) where both Klimt and Kokoschka had studied) but at the Vienna Academy of Fine Arts. Schiele passed the entrance examinations brilliantly and was admitted into the class of that dedicated foe of modern art, Professor Griepenkerl (Fig. 7).

Luckily for Schiele, the seemingly empty routine of copying from plaster casts and only later from life (Fig. 1) (which did give him a solid foundation in precise anatomical drawing) was brightened by one important event. During his second year as a dissatisfied but serious art student (Pl. 1), he prepared an ambitious series of drawings, executed separately from the Academy assignments. One day he presented himself unannounced at the garden atelier of Vienna's most discussed and controversial living artist, Gustav Klimt (Fig. 58). Without formality the boy thrust a portfolio of drawings at the monk of modern art, asking simply, "Do I have talent?" Klimt's answer was equally laconic. After silently looking through the drawings he responded vehemently: "Much too much!" Klimt's appreciation of that talent took solid form: he recommended him for design commissions at Vienna's respected arts and crafts association, the *Wiener Werkstätte*, exchanged or bought drawings from him, and later sent him models as well as clients. Encouraged by Klimt's praise, Schiele the student quickly passed—at least in his own conception—to Schiele the full-fledged artist. The change and resultant cocky attitude in class was too much for the glum Griepenkerl, who was at last prodded to explode: "Schiele! The devil has brought you into my classroom!" This train of events led to the thirteen-point reform petition which irrevocably ended Schiele's Academy career and marked his debut as a member of the *Neukunstgruppe*.

The *Neukunstgruppe* did not take Emperor Franz Josef's capital by storm. Schiele's first independent works, exhibited at Klimt's invitation in Vienna's great *International Kunstschau* of 1909, struck many viewers simply as weak imitations of Klimt. Indeed these first canvases, especially the early portraits, did demonstrate an indebtedness to the Art nouveau or *Jugendstil* aspects of Klimt's style, with emphasis on ornament and elegant silhouette. But there was much to see and study at the *International Kunstschau* and Schiele was quick to absorb features from the work of the foreign artists whom he found the most interesting and the most modern: Vincent Van Gogh, Jan Toorop, Fernand Khnopff, Edvard Munch, Ernesto de Fiori, Felix Valloton, Lovis Corinth, Ernst Barlach, and Georges Minne.[6] Schiele soon began work on an ambitious life-size portrait of *Gerti* (Fig. 16 and Pls. 2, 83a, 84b) in which the first hints of his future direction occur. Superficially the painting, with its incisive contour containment of the figure, resembles the format of Klimt's famous society portraits, such as the painting *Fritza Riedler* (Fig. 17), which since 1907 had been on permanent display at the *Wiener*

Werkstätte showrooms. The handsome device of contrasting body volume with a flowery "fill" was a favorite convention not only of Klimt but also of contemporary photography (Fig. 18). But there was one important difference between the two portraits: Schiele's subject is posited dead center, whereas Klimt's occupies the right-hand portion of the canvas—activating the Art nouveau pictorial principle of disparate halves. The rejection of *Jugendstil* asymmetry in favor of a charged central core was a decisive formal step for Schiele. Intensifying the human silhouette by isolating it in the center of a visual void, he forged the psychological tools necessary for that unrelieved existential concentration which would enable him, like Van Gogh and Munch, to sound and reveal the pathos of the psyche.

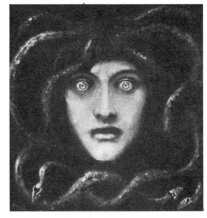

19. Franz Stuck, *Medusa*, 1892. Oil. Private collection.

The new austere form, with its brittle rather than mellifluous silhouette, was complemented by a sobriety of content. The low-key colors of the *Gerti* portrait reinforce the withdrawn, remote quality of the sitter, whose eyes are closed and whose face is turned away in profile. This formula of isolation within a compositional and psychic void was perfected and repeated by Schiele during the latter part of 1909 and 1910 with successful "Expressionist" results. His psychological range extended from phenomenological immediacy (Pls. 3, 5) to angst-filled confrontations with existence (Pls. 4, 6, 7, 54). For the older *Jugendstil* generation such as Klimt and Stuck, the presence of the Irrational, which Nietzsche had declared animated human history, was recognized but relegated to archetypes like the femme fatale, whether her name was Pallas Athene (Fig. 9), Salome, Judith (Fig. 32), or Medusa (Fig. 19).

The awesome revelation of Expressionist portraiture—intuitively paralleling the new science of psychology—was that the spectacle of the psyche could surface in anyone and everyone. By painting *individuals* rather than types, Gerstl, Kokoschka, and Schiele from 1907 to 1910 forced a new dimension upon the concept of portraiture. Whether expressed in the painterly turbulence of Gerstl and Kokoschka or in the terse linear language of Schiele, this new reality gave visible proof of the sense of anxiety now pressing against the disintegrating facade of Viennese aestheticism.

20. Schiele, detail of *Eduard Kosmak*, 1910.

Schiele's pursuit of essence was that of a draftsman; his powers of swift graphic comprehension were equal to those of Toulouse-Lautrec, whom he greatly admired, and, as with the French master, color could provide pungent commentary, but it could never substitute for form. It was not the subtlety of Lautrec's "thin" line however that best served the young Schiele, but rather the posterlike clarity of the "thick" contours employed by Ferdinand Hodler (1853–1918), the great Swiss symbolist painter of portraits, allegories, and landscapes. Hodler's sense of drama (Fig. 21) and eloquent body language (Figs. 28, 47, 49) provided a consistently tapped source for Schiele's own style and subject matter. Line, not color then, was to be the vital and dis-

13

21. Ferdinand Hodler, detail of *Study for the Orator,* 1913. Oil. Museé d'Art et d'Histoire de Genève, Geneva.

22. Schiele, detail of *Study of Otto Benesch,* 1913. Black chalk. Private collection, Vienna.

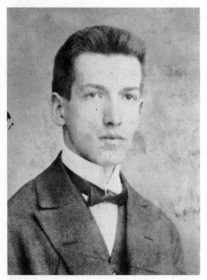

23. Otto Benesch (1896–1964). (Photograph, Collection Eva Benesch, Vienna.)

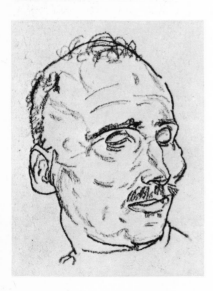

24. Schiele, detail from *Gustav Klimt on His Deathbed,* 7 February 1918. Black chalk. Collection Viktor Fogarassy, Graz.

tinctive basis of Schiele's brand of Expressionism.[7] After 1914 the portraits and portrait studies grew perceptibly less subjective and not so exclusively concerned with the phenomenon of being. Traces of "environment" were occasionally allowed, especially in later works (Pls. 23, 28, 66, and 68). It was Schiele's ability to reduce the plethora of visual data to graphic shorthand that continued to provide the uncanny photographic immediacy so characteristic of his entire oeuvre.

The seismographic line with which Schiele first recorded the psychic disturbances of others was turned with even greater insistence upon that most elusive of facade-encrusted subjects—the self. His autoscopy was inspired by the same compulsion to document the self as that which had motivated the disturbed Gerstl, but in Schiele's case the self-voyeurism ultimately proved salutary. And voyeurism it was: a spying upon the psyche in its most intimate moments through the keyhole complicity of a large standing mirror (Fig. 59). At first self-induced brooding pathos absorbed the artist's attention (Pl. 9), but soon the drama of the slyly exposed, flaccid body and red knuckles of the huge hanging hands in the 1909 *Self-Portrait Nude* (Fig. 5 and Pl. 8) was encouraged to proceed. Schiele the voyeur-artist urged Schiele the model across the threshold of the permissible and into a taboo act of exhibitionism—masturbation (Pl. 12). At the very period when Freud was finding it a somewhat uncomfortable subject to discuss with one of his sons, Egon Schiele was ambidexterously staging and drawing the activity for posterity. Schiele provided in other self-portraits a variety of psychological settings for his auto-eroticism: insatiability, compulsion, self-denial, interruption, release, exhaustion, and guilt. As with the proxy dismemberment theories of psychology Schiele now devised severe "punishments" for the crime exposed in his mirror. Further self-portraits show varying penalties imposed on the body, through cramping spasm or compositional amputation of arms and legs[8] (Pl. 10).

The pathos conveyed by these new icons of the psyche under stress is indisputable; whether the "terror" expressed by Schiele was sincere or simulated is more difficult to determine, since we do not know if he subscribed to the generally held belief that excessive masturbation could produce madness. Certainly Schiele's ruminations on the genesis of his father's insanity had fostered a fixation on his own sexual drives. The somber series of self-portraits which dominated his work during the years 1909 through 1912 constituted a theater of the self in which exhibitionism, narcissism, and sexual gratification battled for center stage. In the long run the fact that Schiele was able to exhibit his "solitary vice"— in front of his mirror through the communicative medium of art —had a therapeutic effect, and the sexual requirements of his later years found company and fulfillment in marriage and extramarital activity. The urgency of Schiele's early sexual manifestos gave way to the cool professional and traditional voyeurism with which he

14

drew the specific pictures of erotica always in demand by some of his clients.

Did the real-life Schiele actually resemble his gesticulating, "ugly" self-portraits? Or were the repulsive images perhaps a *Dorian Gray* adumbration of psychic excess? The many photographs of the artist (see pages 73–127) and the descriptions left by family and friends corroborate an uncommon appearance: "A thin young man of more than average height and with an erect, unaffected posture. A pale but not sickly small face, great dark eyes and luxuriant dark brown hair which stood up from his head in uncontrolled long strands."[9] "When spoken to he turned large, dark, astonished eyes—which had first to chase away the dream that possessed them—upon his interlocutor."[10]

Were the dreams that possessed Schiele unique to him, or were they the same dreams that many others—at least fragmentarily—have known? "Have adults forgotten how corrupted, that is, how sexually driven and aroused they themselves were as children?" Schiele once wrote, adding, "I have not forgotten, for I suffered excruciatingly from it."[11] This sympathizing acknowledgment of the adolescent body on fire was extended by Schiele even to depictions of Gerti (Pl. 11).

The *content* of Schiele's Expressionism then was a heightened sense of pathos and impending doom, and an acute awareness of the self. Schiele's Expressionist *form* drew from the great European reservoir of Symbolist evocativeness. The silent tableau of gestural imagery available to Viennese artists included the eurythmic allegories of Hodler (Figs. 28, 47, 49), the poignant sculptures of Rodin and Minne (Fig. 27), the widely dispersed engravings of Felicien Rops and Munch (Figs. 26, 42), and the "low" popular art forms of such kitsch illustrators as the ubiquitous "Meister Fidus" (Hugo Höppener, 1868–1948), whose panerotic health-in-nature images appeared from 1895 on in the pages of *Pan, Jugend, Simplizissimus,* and other Art nouveau magazines (Figs. 25, 45). Just as Klimt had not hesitated to use enigmatic, frozen gestures in the creation of haunting archetypes (Figs. 9, 32), so Schiele soon learned to reinforce the "pathological" facial expressions in his portraits and allegories with trenchant gestures and a distinctive body language. Both Schiele and Kokoschka were intrigued by the "Gothic" boniness of Minne's small marble statues of kneeling youths (1898), one of which they were able to admire at the *International Kunstschau* of 1909 (Fig. 27). For Schiele the eloquent self-hug of Minne's attenuated figure, who leans forward to observe his watery image, disclosed an existential statement of isolation far beyond the Narcissus legend. With exquisite tenderness, Schiele transferred the Belgian artist's protective, self-containing gesture to his portrait study of Gerti (Pl. 11), accentuating the vulnerability of her exposed body. Another Belgian artist who made an impact on Schiele was Rops. Rops's inspired gesture of apprehension—hands clasped

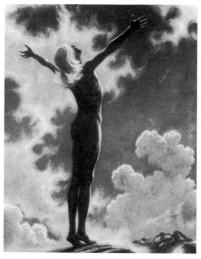

25. Fidus, *Prayer to Light.* (From *Jugend,* Munich, 1904.)

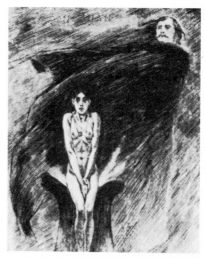

26. Felicien Rops, *Don Juan's Greatest Love,* 1886. Heliogravure.

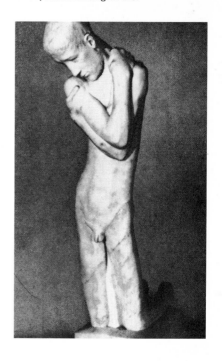

15

27. Georges Minne, *Kneeling Boy,* 1898–1900. Marble. Museum des 20. Johrhunderts, Vienna.

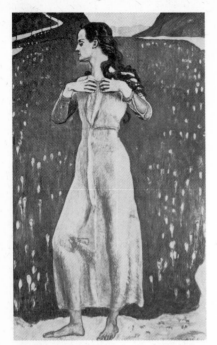

28. Ferdinand Hodler, *Determination*, 1902. Oil. Museum des 20. Jahrhunderts, Vienna.

29. Oskar Kokoschka, detail of "Eros," from *Die Träumenden Knaben*, 1908. Color lithograph.

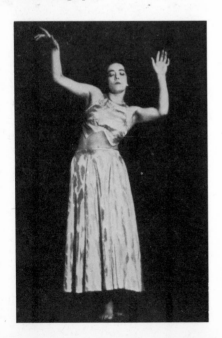

between the thighs—in *Don Juan's Greatest Love* (Fig. 26) had been unforgettably codified by Munch in his famous painting *Puberty*. Now Schiele, responding to the double example of Rops and Munch, applied the same hands-between-thighs motif as a powerful conveyor of individuation in his extraordinary 1910 portrait of *Eduard Kosmak* (Pl. 7; see also Pls. 4 and 59). The optimistic openness of Meister Fidus's world-embracing gesture (Fig. 25), so akin to the ethereal, expansive dance movements of Art nouveau's Loïe Fuller, the Wiesenthal Sisters, and Isadora Duncan, was alien to the Expressionist vision. It was rather the shrinking self-embracement within a hostile environment, as implied in the Minne and Rops prototypes, that broadened the vocabulary of the Viennese artists.

A rich grammar of Expressionist body imagery was assembled by Oskar Kokoschka in the eight-color lithograph illustrations to his "fairy-story" *Die Träumenden Knaben* (The Dreaming Boys), published by the *Wiener Werkstätte* in 1908 (Fig. 29). This bittersweet treatment of the adolescent psyche racked by awakening desire drew heavily from Hodler's eurythmic paralleling of people and nature (Fig. 28). The trancelike, shuddering attitudes of both Hodler's and Kokoschka's figures prefigured the exponent of modern dance whose idiom most closely approached that of Expressionism—Mary Wigman (1886–1973). The restive somnambulism of Wigman's solo performances (Fig. 30) sought to replace appearance with essence. With her emphasis on the broken silhouette, Wigman created a jagged, angular body language that forcefully expressed, rather than merely interpreted, inner emotions and states of feeling. In Switzerland after 1914 Wigman's avant-garde dances—performed on a bare stage—became the Expressionist continuation of Hodler's great Symbolist ballet, in which monumental figures moved within an Art nouveau environment of harmonizing nature. The new psychological concerns of Expressionism thus soon found parallels in the syntax of modern dance, and would be put to effective use in the German Expressionist cinema of the 1920s.

The gestural repertoire available in *The Dreaming Boys* was carefully studied by Schiele, who purchased his own copy of the slim volume from the *Wiener Werkstätte*. The vigorous figure silhouettes led him back to a greater appreciation of Hodler's linear clarity, and the enigmatic poses inspired him to develop a quixotic sign language of his own to dramatize his self-portraits. Conscious of the implication in his family name—*schielen* means "to squint" in German (a fact which hostile critics gleefully seized upon, see Pl. 92c)—he introduced a distinctive gesture of pointing to one eye, while with the same fingers pulling down the flesh of the cheek below (Figs. 31, 34). This created a squint and became an overt visual pun on a "secret" signature. That the gesture also agreed with similar traditional usages in art (Fig. 33) could not have pleased Schiele more. A 1904 illustration from

16

30. Mary Wigman (1886–1973) in *Monotonie 2*. (Photograph, private collection, Switzerland.)

Jugend (Fig. 35) may have triggered one of the artist's most effective stratagems for suggesting vulnerability: the exposed torso and the hair of the head standing on end as though electrified (Fig. 36). Whether transforming visual sources from traditional or from popular art (Hodler too sometimes used the energized hair of caricature), Schiele's final product was exclusively his own patois, bristling with a rawboned terseness of content and form which made his work increasingly distinguishable from that of the most formidable of Klimt icons. Even their signatures betrayed the real chasm that separated these two representatives of radically different epochs. Klimt's fluid, elegant, embellished scrawl (Fig. 60) was a faithful microcosm of the multiple stimuli and sensations in which he felt at home. Schiele's aggressive, self-confirming thick block lettering (Fig. 61) boxed itself in from the void so keenly sensed by his generation.

Schiele could shake an allegorical fist at the existential vacuum about him, but he could not insulate himself from society. A shocking and unexpected impingement on his private life occurred on 13 April 1912. On that day at the door of the isolated garden house he had rented in Neulengbach, a village some twenty miles from Vienna, two constables appeared with a search warrant. The drawings in his bedroom (Pl. 56) were confiscated, and a few hours later he was taken to the town jail and hustled into a basement cell. His reputation for risqué drawings, and the fact that he openly shared the garden house with his model, Valerie Neuzil (his "Walli") (Pls. 17, 85b), had not endeared him to the villagers. Charges of "immorality" and "seduction" had been filed against him. He was detained without bond and a court trial was not held until twenty-four days after the arrest. News of his imprisonment reached Vienna, and one of the few friends to visit him in his cell was Heinrich Benesch (Pl. 59), who brought watercolors and drawing material to the unhappy prisoner. This thoughtfulness made possible the creation of one of the most poignant documentations of suffering known to modern art. During his imprisonment Schiele kept a diary,[12] drew, and made some thirteen watercolors. The fluctuations of his flagging spirits, as each day passed with no hint of release or trial, were recorded in the content of the watercolors as well as in the diary. The first pictures were devoted to meticulous renditions of immediate surroundings—the primitive cell and its adjacent corridor (Figs. 37, 38), and such objects as his clothes, water bucket, and chair. But these devised distractions could not last. Schiele's horror at the injustice of his imprisonment took over in an outburst of self-portraits showing himself as a flailing, uncomprehending, miserable victim. His resolve to endure to the end for the sake of his art and his loved ones—the title he gave to the final self-portrait of the series (Pl. 14)—was put to severe test at his trial. The judge held one of the drawings over a candle flame and let it burn, just as Schiele's father had done a decade earlier. This public condemna-

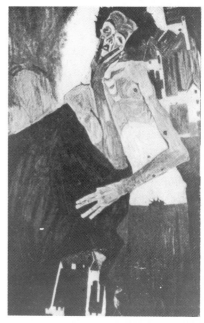

31. Schiele, *Melancholia,* 1910. Oil. (Lost; from Kallir *Oeuvre Catalogue.*)

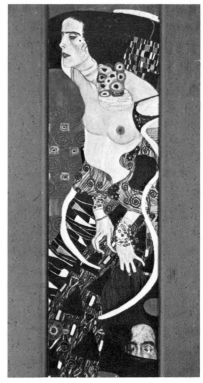

32. Gustav Klimt, *Judith II,* 1909. Oil. Galleria d'Arte Moderna (Ca' Pesaro), Venice.

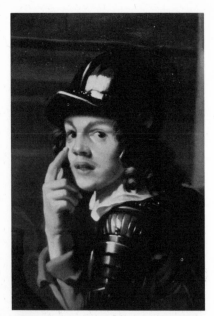

33. Karel du Jardin, detail of *The Story of the Soldier*, c. 1657. Oil. Yale University Art Gallery, New Haven.

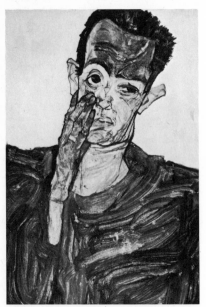

34. Schiele, detail of *Self-Portrait with Fingers to Eye*, 1910. Black chalk and gouache. Graphische Sammlung Albertina, Vienna.

tion seared Schiele permanently and branded with bitterness his image of himself and the darkling content of his allegories.

Friends attempted to comfort and divert Schiele after his release from prison; several portrait commissions were secured for him (Pl. 16), including one from Heinrich Benesch who came up with an intriguing proposal: a double portrait with his son Otto. The idea pleased Schiele, who saw in the seventeen-year-old Otto (Figs. 22, 23) a kindred spirit straining against the often inhibiting bonds of a father-son relationship (Pl. 59). Schiele had rightly sensed an affinity with the son. Otto Benesch later became a distinguished art historian whose writings defended Schiele and introduced him to an international public. Another friendly gesture was made by the art critic Arthur Roessler (Pl. 85a)—an invitation to his summer retreat. Schiele arrived with Walli (Pl. 85b), a trunkful of art books, and a withdrawn and moody frame of mind. His oscillations between surliness (Pl. 85c) and self-pity (Pl. 15) paralleled an increasing restlessness.

If only he could get away to Paris! If his monied patrons would help him now to leave the country. But pleas, cajolery, and threats were in vain. His attitude became that of revengeful rebellion. He had been condemned as an artist, so now he directed his art toward cultural anarchy, throwing homemade bombs of incendiary imagery at church and society. He began to create vivid posterlike pictures with provocative titles such as *Cardinal and Nun* (an explication of what Klimt had only symbolized in his famous painting *The Kiss*) and a provocative *Death and Maiden* (Pl. 26). Desperately in need of money, he redoubled his output of nude studies (Pls. 18, 65) and erotica (Pl. 64b).

Casting himself as monk, hermit, or saint, he backed into an antisocial corner. This self-imposed isolation provoked an extraordinary artistic compensation: companionship returned in the form of a double—a genuine second self in the best *Doppelgänger* tradition. Schiele had previously painted his imaginary twin in a 1910–1911 oil series of double self-portraits in which a victim and a culprit fought out the battle of autoeroticism. The narcissism involved in such mirror fixation generated variations in 1914 and 1915 which included trick photography to provide a second self (Pl. 60). Sketches were made for a life-size canvas in which the "new" Schiele might shed the "old" and "soar" away from earth (Pl. 70b; realized in the painting *Soaring* of 1915). The result was chillingly literal depictions of the divided self (Pl. 61).

The "schizoid" course which the artist seemed to be following can be linked to a turn of events in his private life. Reluctantly reconciled to Vienna, but determined to avoid it as much as possible, Schiele had rented a top-floor studio in an outlying country district. As the year 1914 began, the self-exiled hermit (who was still enjoying the company and modeling services of Walli) worked in morose intensity by his studio window. Directly across

the street lived the Harms family, whose two vivacious daughters had already spotted their handsome new neighbor. Schiele devised a characteristic ploy for meeting the two girls. He created a cinematographic procession of gesticulating seminude self-portraits (Pl. 19) and flapped the sequence out his window at the scandalized but returning audience of two. There were soon "chance" meetings in the street and the nearby park. Which of the two attractive Harms sisters (Pl. 86a) did Schiele favor? Adele, the elder, impetuous brunette, or Edith, the accomplished piano-playing blonde? As late as 10 December 1914 it perhaps did not matter, as proved by an embellished "formal" invitation (Pl. 86b) to them from Schiele to go to the cinema with him and a "chaperone"—Walli.[13] But several movies later a note from Edith to Egon (Pl. 87b), written in the intimate "Du" form and ending with an enthusiastic declaration of love,[14] shows that Schiele had indicated his choice, at least as to which sister he would ask to marry him (Pl. 89c). The courtship—permitted by the somewhat startled but acquiescent parents—progressed apace, although Schiele still planned on "retaining" Walli. He did paint and place over his bed a symbolic and gruesome farewell to Walli in the self-portrait allegory *Death and Maiden* (Pl. 26), but he also composed a "legal" contract which he presented to the baffled Walli soon after his wedding to Edith—a contract in which he promised to spend several weeks each summer with her (an obligation from which both Walli and Edith speedily excused him). The proposed double role of husband and lover for which Schiele felt himself to be so eminently qualified may thus be a contributing factor to the dualism portrayed in the "schizophrenic" double self-portraits of 1915. Schiele was to play a double role throughout his marriage, enticing even sister-in-law Adele into providing promising and intimate poses for both his drawing chalk and his camera lens (Pls. 88a, 88b).[15]

Schiele's occasional philandering (and its thematic proliferation in his work) may have been encouraged by the ingrained prudery of Edith, the "sweet Viennese girl" ("süsses Wiener Mädl") (Pl. 20) and virginally inexperienced young bride (Pl. 21). Schiele had, perhaps, fallen for a "facade." Edith, a product of good petit bourgeois training, was initially not prepared to match or even comprehend the libidinous interests of her experienced husband. Schiele's ubiquitous mirror reflected the first difficult months of their marriage. The hapless embraces between husband and wife, relentlessly recorded by Schiele (Pl. 21), provide extraordinary insights into the mutuality of inadequacy and frustration. Schiele is at his most extreme: eros without pleasure. And yet none of the artist's works dealing with erotica, whether the racked watercolor images of 1910 (Pls. 10, 11) or the coolly distant black chalk figures of 1918 (Pl. 64b), are ever joyous. The pulsating libido of Klimt's gloriously panerotic interpretation of man and nature shriveled before the laser beam of

35. A. Weisgerber, detail of *The Mountain Ghost,* 1902. (From *Jugend,* Munich, 1904.)

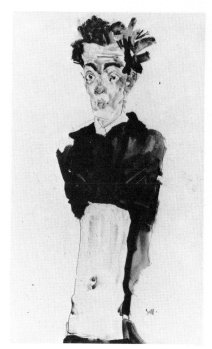

36. Schiele, *Self Portrait with Exposed Torso,* 1911. Pencil and watercolor. Graphische Sammlung Albertina, Vienna.

19

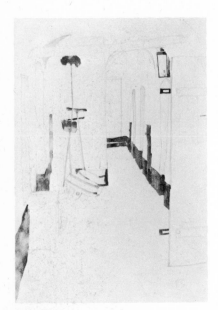

37. Schiele, "I Feel Not Punished But Purified," 20 April 1912. Pencil and watercolor. Graphische Sammlung Albertina, Vienna.

38. Schiele's prison corridor at Neulengbach. (Photograph by the author, 1967.)

Expressionist intensity. Schiele's erotic *confrontation* forever interrupted the sensuous *contemplation* of Klimt's facade-fixated world.

The date of his own parents' wedding anniversary, 17 June, had been chosen by Schiele for his marriage to Edith in 1915. Three days later he was drafted. Edith joined him in Prague, where he was sent for a few weeks of basic training, and then the pair returned to Vienna, where Schiele was allowed to live at home when off duty. The rigors of army life were actually beneficial for the artist—who suddenly found himself with a new, respectable identity and "belonging" within society (Pls. 91a, 91b, 91c). The marriage also improved. As regularity replaced the unusual in Schiele's domestic expectations the young couple grew more compatible and affectionate. The later portraits of Edith (Pls. 62, 63) exhibit great tenderness, and Schiele especially delighted in depicting her wearing the cheerful dress she had made from his striped studio curtains (Pls. 63, 89a, 89b). This willingness to admit quotations from the surrounding environment became a distinguishing feature of his last portraits, indicating a shift from the "void" images of 1910 to a contextual approach (Pls. 23, 66). The bristling linearity of the early portraits (Pls. 3, 5, 6, 9, 10, 11, 13, 54) was replaced by a more painterly application of the black chalk, with interior modeling flecks on the face and hands (Fig. 24 and Pl. 67), but with no diminution in the uncanny sureness of the draftsmanship.

Even Schiele's self-imagery ultimately showed a softening of the former urgency. The best example of this mellowing is provided in the photographs for which the artist posed so willingly throughout his life. All consistently show the same high-strung individual, usually with clenched or hidden fists (Pls. 85a, 85b, 92a, 92b). The early psychodramas enacted against a nil, of the 1914 series of photographs (Fig. 40 and Pl. 85a), not only parallel Mary Wigman's expressionistic dance attitudes, but are also strikingly similar to the smoldering theatrics of the actor Ernst Deutsch (Fig. 39).[16] The later photographs of the artist include his environment—the full-length mirror and handmade chair of his studio—and reveal a sobriety more profound and far-reaching than the earlier self-conscious gesticulations. The exploited self-pity animating Schiele's first images of himself became, after the outbreak of a world war, a genuine pathos of human and humanizing dimension.

It was the unfolding humanitarianism of Schiele's anxiety-beset world view that endowed his prolific series of allegories and landscapes with their undeniable sense of exalted content. Arthur Roessler (Pl. 85a), the critic who had early befriended Schiele, methodically collected the artist's work. A photograph of Roessler's study wall (Fig. 41) shows examples from each of the three major subjects that attracted Schiele's attention: portraiture, represented by the 1911 *Self-Portrait with Spread Fingers* hung at the bottom; landscape, with a 1911 view of the town of Krumau

in the center; and allegory, with a "Mother and Child" painting of 1910 at the top. It was Roessler who suggested the theme of motherhood to Schiele during Christmas week of 1910. The young artist had been complaining about his mother's (Pl. 81a) constant interference and her questioning of his "obligation" to paint at times "ugly" pictures. Roessler proposed that Schiele relieve his frustration by painting a series on different kinds of motherhood, such as "unwed mother," "stepmother," and "blind mother." Schiele returned the next day with his catharsis: a not yet dry small oil on wood pointedly entitled *Dead Mother* (Fig. 41, top).

This seeming wish-fulfillment had however recent artistic prototypes from which Schiele drew to create his macabre contrast of rosy-fleshed child and ashen-colored mother. Max Klinger's etching "Mother and Child" of 1889 (Fig. 42) was pointed to by Roessler himself in a review of Schiele's work. Locally, Klimt had treated the theme of prospective motherhood threatened by the specter of death in his daring 1903 excessively pregnant nude *Hope*, repeating the theme with a clothed variation in 1908 (Fig. 43). Schiele's reduction of the Klimtian cast of characters to mother and womb-encased child is typical of the Expressionist intensification toward which he was striving. His earliest "allegories" had attempted to combine Klimt's decorative symbol-saturated environments with poignant imagery, as in the 1909 *Danae* (Pl. 52a), directly inspired by Klimt's *Danae* of the year before. Schiele had used Gerti as the nude model (which perhaps explains his mother's "interference") and again posed her provocatively (Pl. 52b) in a first study for probably a Salome or Judith based on Klimt's own glitteringly successful *Judith* of 1909 (Fig. 32). The impact of the work of Minne and Van Gogh at the *International Kunstschau* of 1909 persuaded Schiele to drop the allegorical "facade"—in his drastic 1910 exposure of Gerti's psyche (Pl. 11).

But Schiele continued to mull the possibilities of allegories or icons of motherhood in his sketchbooks (Pl. 69b) and painted several more "dead" and "blind" mothers.[17] The series was enriched by a darkly glowing *Madonna* of 1911 (Pl. 24) in which a tremulous apprehension united the pale and fragile pair against a murky, indistinct background. In the same year Schiele painted his own version of Klimt's pessimistic *Hope* images in an allegory *Pregnant Mother and Death* (Pl. 58). The artist himself appears as a tonsured monk of Death confronting a swollen, pregnant woman whose head is bent in resignation.

The preoccupation with death in his allegories, and with autumnal decay in his landscapes, is the other side of Schiele's thematic coin. The obverse reflected eros and the reverse mirrored a particularly Viennese ethos of death. The close connection between love and death—a favorite topic of Expressionist writers—had been given real-life dramatization in the short career of a tormented contemporary, Otto Weininger (Fig.

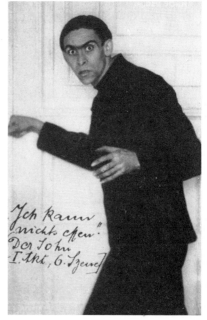

39. Ernst Deutsch (1890–1969) in the title role of Walter Hasenclever's play *The Son,* 1914. (From *Expressionismus* catalogue, Munich, 1960.)

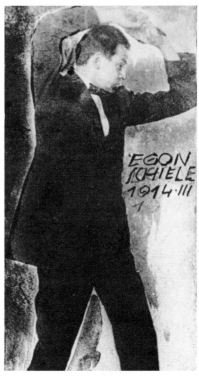

40. Egon Schiele in 1914. (Photograph by Anton Joseph Trčka.)

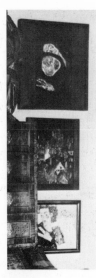

41. Detail of Arthur Roessler's study wall showing three paintings by Schiele (Photograph, Roessler Estate, Historisches Museum der Stadt Wien, Vienna.)

42. Max Klinger, detail of "Dead Mother" (1889), from *Death,* Opus XIII, 1885–1909. Etching.

43. Gustav Klimt, *Hope II,* 1907–08. Oil. Private collection, Vienna.

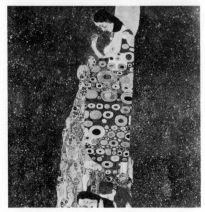

44). His 1903 *Geschlecht und Charakter (Sex and Character)* was a deranged and hysterical book which had brought him overnight success. For a long time it was advertised monthly in *Jugend* and was in its seventeenth edition by the time of Schiele's death in 1918. It equated all cultural accomplishments with a male principle and linked the restraints of civilization with women and Jews. Fleeing from the bisexuality acknowledged in his book and from his own Jewishness, Weininger equated coitus with murder[18] and solved his problem by suicide shortly after his book appeared. Schiele, strongly desiring the immortality he believed his work would bring him, never contemplated suicide, but attempted to hold death at bay by the same means he had used to control eros: thematic aggression and repetition.

The appearance of Schiele as one of the somber protagonists in his own allegories was entirely consonant with his self-absorption. Even before his Neulengbach arrest and subsequent retreat into the antisocial role and self-imagery of ascetic hermit, he had cast himself as a medieval monk. This was not only imitation of Klimt's monastic manner of dress, but also a nostalgic response to a vanished period in art. His attenuated-figure style had caused critics to refer to him as a "new Gothic painter"—a label that quite pleased Schiele. The titles of his allegories—many of them now lost—suggest the visionary temper and dramatis personae of the Middle Ages: "Revelation," "Vision," "Ascetics," "Conversion," and "Saints." The allegories still surviving, such as the 1912 *Conversion* (Fig. 46), or known through photographs, such as the *Procession* signed and dated 1911 (Fig. 48), show Schiele as monklike ascetic, enigmatically gesticulating at two nunnish versions of Walli as blonde and as brunette novitiates; or rigidly frontal and heavily robed, standing next to a somnambulistic Walli swathed in similar garb. These abstruse allegories suggest Schiele's anxious response to the spectacle of life and death; their earnest messages are full of personal anxiety and real pathos. "Why do I paint graves and similar pictures?" Schiele once asked, answering, "Because these things are continuously alive within me."[19] The bewildering ambiguity of his "Gothic" allegories—half sinister, half sorrowing—is an amplified statement of the melancholy in the tortured self-portraits. Visual precedents again range from low to high art: Meister Fidus's unabashedly titillating *Conversion* appeared in a 1904 issue of *Jugend* (Fig. 45); Hodler's monumental friezes of resignation and despair (Fig. 49) and his *Eurythmy* (Fig. 47), a great procession of five Dürerlike cloaked figures, were openly admired by Schiele.[20] When he borrowed the ascetic image from the Swiss master he expunged its harmonizing nature-environment and set it instead within an existential Nothingness.

Two allegories indebted to the Hodler paragon are also the two most personal. Painted at Neulengbach shortly before Schiele's arrest, they are titled *Agony* (Pl. 25) and *The Hermits*

(Pl. 90a), and the two monks portrayed are none other than Schiele on the left in both cases, and on the right the worthiest of contemporary artistic companions, Klimt. Both paintings can be interpreted as manifestos, not only of Schiele's now ambivalent attitude toward the spiritual master of his teens, but also of symbolic affirmation of the conflict between the two generations and their aims in art. Domination and compositional claustrophobia overwhelm the fainting figure in *Agony*, and defiance bristles in *The Hermits*. The development of this new attitude toward Klimt can be traced in initial sketches. Approval of Schiele by Klimt had been the theme of a 1909 composition in pencil on gray cardboard, *The Pledge* (Pl. 53a). Here the slim figure of Schiele, his brow characteristically furrowed, is dominated compositionally by that of Klimt, whose spreading mantle fills the space like an organic growth. By 1912 Schiele's sketchbook showed a physical breach between the two monks (Pl. 69a), while the force of the right-hand figure—Klimt—was now powerful enough to cause the left-hand figure—Schiele—to recoil, hand lifted in apprehension. Suffering and a pathetic bid for sympathy characterize *Agony* (Pl. 25). A dying monk is "blessed" by a companion, as the compelling figure of Klimt advances with hypnotic intensity upon the swooning Schiele. A mute challenge and affirmation of self lies in the unusual placement of Schiele's signature, set into the upper right-hand corner of the canvas at a level with Klimt's face. The charged emotions of the picture animate and are refracted by geometric color divisions of the rocky, abstract background—a far cry from Hodler's eurythmic surrounds.

Retaliation and a kind of sinister triumph lash out in the pen and ink study (Pl. 53b) for *The Hermits*. Klimt, drawn twice, is shown *deprived of sight*—whether actually fantasized as blind, or simply symbolically seeled. The older man is sightless, his figure pressing or bumping against that of Schiele; he is now a pathetic has-been, led by his "son," whose belligerent stance and defiant gaze are deliberately intended to engage the attention of the beholder. Just as Schiele had equalized the social standing of the two artists—the one favored, the other shunned by society— by casting them in the guise of hermits, so now he made a challenging prediction: the "modern" art for which he stood would displace the waning "old" style of painting, as represented by Klimt and his golden facades. "I shall come so far that people will take fright before the greatness of one of my 'living' works!"[21]

Klimt himself did not shrink before the implication of this painted manifesto, and indeed *The Hermits* was considered by contemporaries to be Schiele's homage to the senior artist. Schiele's resentment was purged through these allegories. His original affection and respect for Klimt prevailed, and in 1918 he tenderly sketched his friend on his deathbed (Fig. 24). Certainly Schiele's need to defy the established order abated after his marriage and induction into the army, and with increasing financial

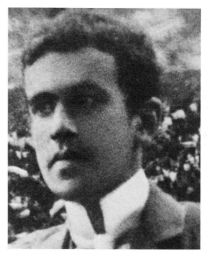

44. Otto Weininger (1880–1903). (Photograph from O. Weininger, *Geschlecht und Charakter,* Vienna, 1903.)

45. Fidus, *Conversion,* 1901. (From *Jugend,* Munich, 1904.)

46. Schiele, *Conversion,* 1912. Oil. Private collection, Vienna.

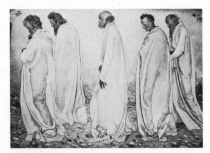

47. Ferdinand Hodler, *Eurythmy,* 1895. Oil. Kunstmuseum, Berne.

48. Schiele, *Procession,* 1911. Oil. (Lost; photograph, Collection Gertrud Peschka, Vienna.)

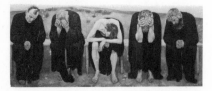

49. Ferdinand Hodler, *The Disillusioned Ones,* 1892. Oil. Kunstmuseum, Berne.

success and artistic recognition.

The ordeal of a world war forced an abrupt end to the Expressionist luxury of self-absorption, and Schiele's later allegories veered away from the autobiographical, such as *Death and Maiden* (Pl. 26), tending instead to illustrate the themes of birth, love, and death in a more universal application and context. The model for both babies in *Mother with Two Children* (Pl. 27), begun in 1915 and completed in 1917, was his nephew, Gerti's son Toni, whom the artist twice utilized to demonstrate the phenomenon of contrasting personalities—extravert and introvert—even in newborn infants. The "monstrous individuality" (Adolf Loos's phrase) of the psyche was slowly being replaced by humanizing generalization. Even *The Family* (Pl. 28), begun in 1917 and left partly uncompleted, and called by Schiele simply "Squatting Couple," cannot correctly be interpreted exclusively as a personal allegory despite Schiele's use of himself as model for the father. The mother is not, as one might expect, Edith, but a professional model, and the small boy was a later addition, painted in after Schiele learned that Edith was pregnant with their first child.

A new thematic interest attracted Schiele during the final years: he wrote of his aspiration to create monumental religious compositions, and his sketchbooks document a shift from the autobiographical hermit and "saint" (Pl. 70a) who had populated the self-portraits and allegories of his middle years (Figs. 46, 48 and Pls. 15, 58) to essays in familiar religious imagery such as a *Descent From the Cross* (Pl. 70c). The large color-lithograph poster he designed for his March 1918 one-man exhibition at the Secession (Pl. 68) held specific religious overtones. His "disciples"—all fellow artists—are tonsured monks who sit around a table laden with books and earthenware vessels. At the head of this secular Last Supper, in Christ's place, sits Egon Schiele. That notion of privileged status in which the young Academy student had set so much store; that obdurate belief in the freedom of the artist—tested so dramatically by the Neulengbach imprisonment and trial—had sustained him. The depiction of himself as spiritual leader of an elite in this poster advertising his own work was a bold and fervent affirmation of the aesthetic imperative. Fate was on Schiele's side: his one-man exhibition was a decisive financial and artistic success.

The role of landscape in Schiele's oeuvre was prominent. Almost half of the artist's completed oils and many of his hundreds of watercolors, drawings, and sketchbook notations are devoted to city views and landscapes. Nowhere is Schiele's dualism better evinced than in his flight from pathos into the ethos of nature. The joyless explorations of psyche and eros are balanced throughout the artist's productive years by the exalted lyricism of his trees, sunflowers, town scenes, and landscapes. There is no doubt that these topics exerted a soothing influence upon him and were very dear to him. He in turn imposed a tectonic order on

nature, frequently tilting the perspective and planes forward to link fragile or brittle subject matter across a shallow pictorial surface. The psychic tension of his portraits was converted into painterly traction in his architectural vistas: jewellike color wedges animate the shapes and facades of his buildings. Rarely did he mix subject matter. Just as persons were generally presented within a void in the portraits, or against spatial cubes in the allegories, so Schiele's landscapes and town scenes excluded—until 1917 (Pl. 46)—people. The townscapes were pronouncedly uninhabited: views of his mother's home town Krumau in Bohemia, to which he returned regularly and as late as 1917 (Pls. 41, 46), the old town of Stein on the Danube (Pls. 38, 39), and nearby Mödling (Pl. 72c). And yet a certain "humanitarianism" and human affection characterizes these unpeopled works. It is a felt bond, the remembrance of vanished human presences in "dead towns"—as Schiele liked to call his townscapes. The resulting sense of solemn calm (Hölderlin's *Heilignüchtern* intoned at Expressionist pitch) was like that in the transcendent nature imagery of the contemporary poets Georg Trakl and Richard Dehmel and in the nostalgia of Gustav Mahler's symphonic evocations of nature. Schiele, like Trakl, had a particular tenderness for autumn, the season of fiery decay. "An autumn tree can be experienced in summer more profoundly, and with one's being and heart. It is this melancholy that I would like to paint."[22] Schiele's spindly trees and vulnerable flowers breathed an autumnal austerity similar to the pathos-imbued motifs of Van Gogh. The vitalistic message read by Klimt into nature and codified by him into multifaceted, surface-smothering statements of eternal fecundity (Fig. 50) was not for Schiele. Instead, and again like Van Gogh, about whom he often spoke with reverence, Schiele's individual autumn trees and mortal sunflowers are burdened with unbearable intensity. Isolated from nature, their anthropomorphic silhouettes trace out a timeless solitude (Pls. 31, 33). The dispassionate combination of schematism and naturalism—a lesson well-learned from Klimt, Hodler, and Cézanne—heightens the lasting appeal of such works and ranks Schiele as a great constructor.

Retreat into a hermetic world via landscape had been an important and necessary outlet for Schiele since childhood. "He was always outside in the meadows, on the slopes, by the brooks, and drew sheet after sheet . . . quietly and with perseverance as if nothing existed except nature, pencil, and drawing paper."[23] Schiele's earliest works, aside from the innumerable train sketches (Pl. 75b), were predominantly landscapes, either in response to a local event, such as the charming colored pencil drawing *Conflagration in Tulln* (Pl. 49a), drawn when he was ten, or traditional romantic motifs like the watercolor *Sunrise* (Pl. 49b) of around 1905. After meeting Klimt in 1907, he began to flatten his pictures by employing the *Jugendstil* stacking of horizontal planes. One of his first attempts in oil, the *Girl at Forest's Edge*

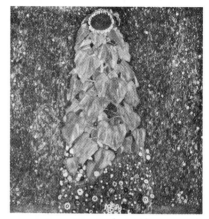

50. Gustav Klimt, *The Sunflower*, c. 1906–07. Oil. Private collection, Graz.

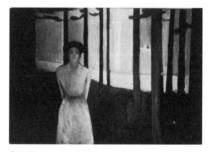

51. Edvard Munch, *Summer Night* (*The Voice*), 1893. Oil. Museum of Fine Arts, Boston.

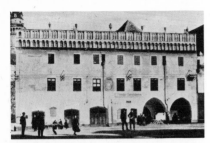

52. Postcard showing the City Hall at Krumau sent by Schiele to Arthur Roessler, 30 May 1911. (Roessler Estate, Historisches Museum der Stadt Wien, Vienna.)

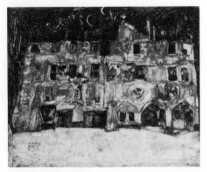

53. Schiele, *The City Hall at Krumau,* 1911. Oil. (Lost; from Kallir *Oeuvre Catalogue.*)

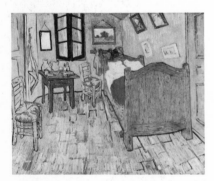

54. Vincent Van Gogh, *Bedroom at Arles,* 1888. Oil. The Art Institute of Chicago.

(Pl. 29) of about 1907, has a likely prototype in Munch's 1893 *Summer Night (The Voice)* (Fig. 51), also known in a drypoint version of 1895. But while Schiele retained the melancholy mood of the Norwegian master's landscapes, he very soon chose to exclude the human figure from his nature scenes, concentrating instead with the same narrowing focus that distinguished his early portraiture on singling out individual motifs such as boats (Pls. 30, 57) and sunflowers (Pls. 31, 33). This insistence on one predominant and rhythmically repeated element—even in his occasional still lifes (Pl. 48)—was developed in the later, more ambitious town- and landscapes. In such works a particular tower, steeply pitched roofs, or faceted facade form focal and repetitive highlights. Like Cézanne, Schiele often emphasized and brought forward the background planes of nature (Fig. 55), painting them with as sharp a focus as the foreground (Fig. 56, Pls. 38, 39). The juxtaposition of near and far color compartments was to inspire the animated patchwork-quilt effects of Fritz Hundertwasser fifty years later (Fig. 57).[24]

Schiele's excitement over the discovery of a single eloquent motif, such as the "Asiatic" bridge of wooden beams spanning the Danube at Györ (Pl. 40), or a brightly shingled sawmill afloat in a sea of green (Pl. 37), could unleash a flood of sketchbook responses (Pl. 72a) and hastily scrawled color notations (Pl. 72b). At other times his approach was more coolly based on photographic aids. Such was the case with a number of his views of Krumau. In order to utilize the oriental piling of planes and yet maintain a pristine volume of forms, he bought commercial postcard views of the city, squared off the section he wished to paint with a pencil grid (Pl. 71c), and set to work through on-the-spot sketchbook notations (Pl. 71b) to achieve the desired trenchant reductions (Pl. 32). Quite often he would send these cards to prospective clients, indicating with a penciled frame the area he was depicting. On the back of a postcard sent to Roessler showing the center of Krumau (Fig. 52), he directed his friend's attention to the "old city hall which I am now painting."[25] Use of photographic intermediaries by no means diluted the Expressionist fervor: Schiele's oil painting of the Krumau city hall (Fig. 53) sweeps out all human incidentals and allows an empty foreground to vie with the pulsating facade of the *Rathaus* in a Van Gogh-like simplicity of confrontation. Schiele liked to recall that he had been born in the same year the Dutch painter died, and he paid specific homage to Van Gogh with an interior scene, *The Artist's Room at Neulengbach* (Pl. 56). As a creative paraphrase on the *Bedroom at Arles* (Fig. 54)—a version of which Schiele had been able to study in the collection of his patron Carl Reininghaus —Schiele's work, without windows or doors, displays the hermetic response of Expressionism to that existential chasm sensed so prophetically by Van Gogh. Two decades later that gulf

between the self and the universe had become the concern of an entire generation.

The *Weltwehmut* (world melancholy) of Schiele's lyrical autumn landscapes and deserted buildings is a pastoral diffusion of the pathos animating the portraits and allegories. Schiele's dualistic vision—the disquieting eros of his interior world, and the palliative ethos of nature—was a dichotomy that found pictorial union only once. In 1910, the year of his most radical dissections of the psyche, the artist painted an agonized image of himself, partially nude, "amputated," and gesticulating, wedged between two versions of his Krumau townscape *Dead City* (Fig. 31). Significantly, he titled the picture *Melancholia*. The message conveyed the sad lesson that even nature was not always vast enough to absorb the burden of existence.

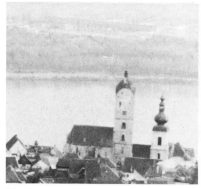

55. Stein on the Danube. (Photograph by the author, 1971.)

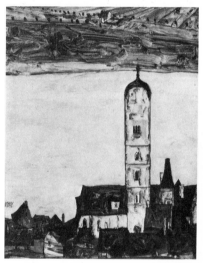

56. Schiele, *Church in Stein on the Danube*, 1913. Oil. Private collection, U.S.A.

The March 1918 one-man exhibition at the Secession brought Schiele acceptance, recognition, money, and commissions. He was able to rent a new studio large enough to house the projected religious murals. On 27 October Austria asked the Allies for an armistice, signaling an end to the great war. Just as life seemed finally to promise happiness, fate with terrible acceleration overtook Schiele. Schiele the soldier had escaped unscathed. But Schiele the civilian was to succumb to the influenza epidemic that ravaged all Europe during the unusually severe winter of 1918. Fuel was scarce and the new studio was difficult to heat. Edith, six months pregnant, came down with influenza on 26 October. She died in Schiele's arms on the 28th. A handwritten note by Anton Peschka on her funeral announcement says "Egon gravely ill" (Pl. 94a). The sculptor Gustinus Ambrosi was summoned at Schiele's request to make a plaster cast of Edith's beautiful hands. But the message was delayed by several days. Edith was already buried when Ambrosi arrived. Another subject awaited him. Stretched out on the bed was the lifeless body of Egon Schiele (Pl. 93). A second funeral notice was mailed out by the stricken relatives (Pl. 94b), and Schiele's death mask was taken (Pl. 95)—a last portrait, dictated by death, of the artist whose troubled psyche had been eased of its world pathos.

He was twenty-eight years old.

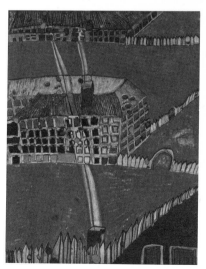

57. Fritz Hundertwasser, *Blood-Garden: Houses with Yellow Smoke*, 1962–63. Mixed technique. Private collection, New York.

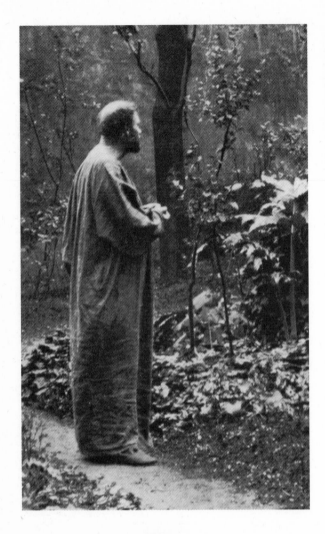
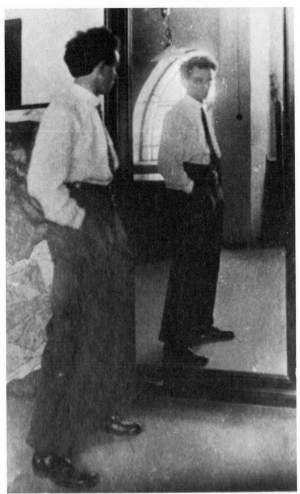

58. Gustav Klimt in His Garden, c. 1910. (Photograph by M. Nähr, Vienna.)

59. Egon Schiele Before His Mirror, 1916. (Photograph by Johannes Fischer, Vienna.)

60. Signature of Gustav Klimt.

61. Signature of Egon Schiele.

NOTES

1. In the summer of 1971 the late Dr. Margarethe Poch-Kalous, then director of the Gemälde Galerie of the Vienna Academy of Fine Arts, kindly allowed me to investigate the Academy premises to see whether any of these drawing stools still survived. A search turned up several of the venerable boxes stacked in a storeroom!

2. Klimt's name was three times suggested and rejected for a professorship at the Vienna Academy during the years 1893-1905. The scandal attached to the "unacceptability" of his three University panels had caused government intervention and censorship of his work. For a fuller accounting see Johannes Dobai's oeuvre catalogue, *Gustav Klimt*, Vienna, 1967 (with introduction by Fritz Novotny), Christian M. Nebehay's *Klimt Dokumentation*, Vienna, 1969, and my companion volume to this book, *Gustav Klimt*, New York, 1975.

3. One of the most effective applications of this "bestial" illumination of face from below—and the "spiritual" transformation made possible by raising the light source to a point above the face—is found in contemporary literature in Ella D'Arcy's short story "The Death Mask," published in 1896 in the tenth number of the shortlived but vastly influential London quarterly *The Yellow Book*. The general fascination of the Decadent and Symbolist writers by the elusiveness of shifting appearances was an important contributing factor to the Expressionists' ruthless ramrodding of the beautiful facade.

4. Peter Altenberg's prose vignettes of the passing scene often contained insights into the motivation and mores of his characters which paralleled the more frontal attack on the hyprocrisy of Viennese society conducted by Karl Kraus and Sigmund Freud. Here is a characteristic bit of Altenberg dialogue:

He and She, sitting on a bench under the linden trees.
She: *"Would you like to kiss me?"*
He: *"Yes, Fraülein."*
She: *"On the hand?"*
He: *"No, Fraülein."*
She: *"On the mouth?"*
He: *"No, Fraülein."*
She: *"Oh! You are indecent!"*
He: *"I was thinking I should like to kiss the hem of your skirt!"*
She turns pale.
(From Peter Altenberg, *Wie Ich Es Sehe*, Berlin, 1910, p. 129; translations of this and all other sources cited in the notes are mine.)

5. The facts concerning Schiele's parentage, early life, and personality I owe to the generous recollections of his two sisters, Melanie Schuster-Schiele (died 29 October 1974) and the still-surviving Gertrud Peschka-Schiele, both of Vienna. From 1962 both sisters willingly granted me frequent interviews, and both kindly allowed me the fullest possible access to their important collections of Schiele's works and correspondence.

6. For a full discussion of the foreign entries at the 1909 *International Kunstschau* see my book *Egon Schiele's Portraits*, Berkeley, 1974, especially chapter III. Vienna did not have to wait for an international exhibition to see modern art

however; the enterprising Galerie Miethke scored several firsts in introducing the city to works of Minne (1905–1906), Van Gogh (1906: forty-five works shown, and several bought by Schiele's future patron Carl Reininghaus), and Toulouse-Lautrec (1909). Hodler had been given exhibitions by the Vienna Secession in 1900, 1901, and again in 1903–1904—a most important retrospective at which thirty-one of his paintings were shown. Seven of these were acquired by Reininghaus for his collection, where Schiele would later have a chance to study them (see Figs. 28, 49) along with the Van Gogh *Bedroom at Arles* (Fig. 54).

7. With the exception of the year 1911, when he used a hard pencil, Schiele invariably favored drawing with black chalk or black crayon (*schwarze Kreide*); he never employed an eraser, and color was applied only afterwards.

8. The thematically complex meanderings of Schiele's sexual odyssey are explored in my book *Egon Schiele's Portraits*, chapters I through IV.

9. Heinrich Benesch in "Mein Weg mit Egon Schiele," hand-written essay dated November 1943 in the album compiled by Max Wagner, "Egon Schiele Erinnerungsbuch" (pages not numbered) preserved in the Egon Schiele Archive, Graphische Sammlung Albertina, Vienna.

10. Arthur Roessler, *Erinnerungen an Egon Schiele*, 2nd ed., Vienna, 1948, p. 6.

11. See note 12 below.

12. Edited—possibly with some changes and deletions—by Arthur Roessler and published after the artist's death under the title *Egon Schiele im Gefängnis*, Vienna, 1922; translated into English and published with a commentary by me as *Schiele in Prison*, Greenwich, 1973. In the summer of 1962 I discovered that Schiele's crude country cell still existed—quite forgotten and stacked with firewood in the basement of Neulengbach's district courthouse. A photographic comparison of the artist's watercolor views of his cell and corridor was made (see Figs. 37, 38 above), and it was possible to confirm the eloquent accuracy of Schiele's pictorial response to imprisonment.

13. Schiele's invitation, reproduced Pl. 86b, translates as follows: "Dear Fraulein Ed. and Ad. or Ad. and Ed. I believe that your Frau Mama will permit you to go with Walli and me to the movies, or to the Apollo, or wherever you want. You may rest assured that in reality I am entirely different from an 'Apache.' That is nothing but a momentary pose out of bravado. If you would like, therefore, to entrust yourselves to me and Walli, I would be delighted, and I await your reply as to which day would be convenient for you."

14. Edith's note (Pl. 87b) reads: "Dear Egon, Unfortunately it is not possible for me to be with you today. I have such a swollen cheek that I cannot show myself in public. Hopefully it will all be over by tomorrow. Shall I come to you tomorrow with Willi [sic]? Give me an answer, but so that no one sees, namely my Mama. I love you so unendingly! Edith"

15. Adele Harms also posed for photographs in the nude for her persuasive brother-in-law (personal interviews, Vienna).

2 November 1966 and 24 January 1967). Her reminiscences of her sister stress Edith's kindly but domineering personality.

16. Ernst Deutsch (1890–1969) lived in Berlin and was a friend of the playwrights Franz Werfel and Walter Hasenclever. In 1914 he created a sensation as the tyrannized son in Hasenclever's play *The Son*—the first successful Expressionist theater piece.

17. A second *Dead Mother* of 1911 (K. 136) was subtitled *Birth of Genius* by Schiele and there was no ambiguity about who the budding genius might grow up to be. On 31 March 1913 the artist wrote his mother the following comforting assurance: "You are at the age when, I believe, one has the driving desire to want to . . . rejoice in the fulfilled and revealed fruits—whose willfulness is innate and grows independent roots. This is the great separation. Without doubt I shall be the greatest, the most beautiful, the most valuable, the purest, and the most precious fruit. . . . I shall be the fruit which after its decay will still leave behind eternal life; therefore how great must be your joy to have borne me." From Arthur Roessler, *Briefe und Prosa von Egon Schiele*, Vienna, 1921, p. 29.

18. See especially pp. 324-325 of Weininger's morbid book. Both Strindberg and De Chirico treasured their copies of *Geschlecht und Charakter*, and sixty-five years after its publication, the inflammatory message of Weininger's misogyny ignited violent—if equally unbalanced—action from the American, Valerie Solanas. Her *S.C.U.M.* (*Society for Cutting Up Men*) *Manifesto* was published in 1968 shortly before she aimed her famous pistol shots at the Pop artist Andy Warhol.

19. Roessler, *Briefe und Prosa von Egon Schiele*, p. 102, a 1913 letter from Schiele to his brother-in-law Anton Peschka.

20. Schiele considered Hodler the greatest living painter after Klimt (see also note 6 above). As late as 1915 he was attempting to obtain from the Munich dealer Hans Goltz a copy of Fritz Burger's out-of-print study of style in modern art, *Cézanne und Hodler* (Munich, 1913): see letter to Schiele from Goltz dated 14 December 1915 in the Egon Schiele Archive of the Graphische Sammlung Albertina, Vienna.

21. Letter from Schiele to his Uncle Czihaczek, 1 September 1911, transcription kindly provided by Anton Peschka, Jr., Vienna.

22. Letter of 25 August 1913 to Franz Hauer, transcription generously provided by Dr. Franz Glück, former director of the Historisches Museum der Stadt Wien, Vienna.

23. A composite description of the young Schiele given by his Klosterneuburg teachers and published in the *Neue Freie Presse*, 1927 (publication date not preserved on the clipping) in the Egon Schiele Archive, Graphische Sammlung Albertina, Vienna.

24. This influence was readily acknowledged by Hundertwasser in a letter to me of 29 July 1963.

25. Postcard, dated 30 May 1911, part of the Roessler estate now in the possession of the Historisches Museum der Stadt Wien, Vienna.

LIST OF PLATES

61. *Double Self-Portrait*, 1915. Black chalk and watercolor. Private collection, Switzerland.

62. *Edith Schiele in Hat and Veil*, 1915. Black chalk, 46 x 28.5 cm. Private collection, Switzerland.

63. *Aunt and Nephew*, 1915. Black chalk, 48.5 x 33.5 cm. Private collection, Switzerland.

64a. *Woman and Child*, 1918. Black chalk, 30 x 46 cm. Collection Ing. N. Gradisch, Vienna (Index 60).

64b. *Self-Portrait with Female Nude*, c. 1918. Black chalk, 52.2 x 134 cm. National Gallery of Canada, Ottawa.

65. *Female Nude*, 1917. Black chalk and watercolor, 46 x 29 cm. Collection Alice M. Kaplan, New York.

66. *Guido Arnot*, 1918. K. 235. Oil on canvas, 140.6 x 109.5 cm. Collection Böck Family, Graz.

67. *Portrait Study of Guido Arnot*, 1918. Black chalk, 47.2 x 32.5 cm. Collection Daisy Bene, Graz.

68. *Round the Table* ("*The Friends*"), 1918. Color lithograph poster for show of Schiele's work at the 49th Exhibition of the Vienna Secession, 68.3 x 53 cm. Private collection, Dallas.

69a. Compositional Sketch for *Agony* (Plate 25). Albertina Egon Schiele Archive, Sketchbook 2, p. 22 recto. Graphische Sammlung Albertina, Vienna.

69b. Compositional Sketch for *Mother with Two Children* (K. 195, 1914). Albertina Egon Schiele Archive, Sketchbook 3, pp. 25 verso and 26 recto. Graphische Sammlung Albertina, Vienna.

70a. Compositional Sketch ("*Two Saints*"). Albertina Egon Schiele Archive, Sketchbook 3, p. 18 recto. Graphische Sammlung Albertina, Vienna.

70b. Compositional Sketch for *Soaring* (K. 206, 1915). Albertina Egon Schiele Archive, Sketchbook 6, p. 12. Graphische Sammlung Albertina, Vienna.

70c. Compositional Sketch for a Deposition from the Cross (not executed). Albertina Egon Schiele Archive, Sketchbook 9, p. 6 recto. Graphische Sammlung Albertina, Vienna.

71a. Krumau on the Moldau, Czechoslovakia (formerly Bohemia). Photograph by the author, 1966.

71b. Compositional Sketch for *Dead City* (Pl. 32). Albertina Egon Schiele Archive, Sketchbook page. Graphische Sammlung Albertina, Vienna.

71c. Postcard with View of Krumau with Area Squared by Schiele for *Dead City* (Pl. 32). Formerly Collection Melanie Schuster-Schiele, Vienna.

72a. Compositional Sketch for *The Bridge* (Plate 36). Albertina Egon Schiele Archive, Sketchbook 1, p. 27 verso. Graphische Sammlung Albertina, Vienna.

72b. Compositional Sketch for *The Sawmill* (Plate 35). Loose sketchbook page. Formerly Collection Wolfgang Gurlitt, Munich.

72c. Compositional Sketch for *Mödling* (1916, K. 215). Albertina Egon Schiele Archive, Sketchbook 7, p. 11. Graphische Sammlung Albertina, Vienna.

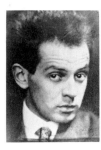

A Schiele Photograph Album

Photographs courtesy the Albertina Egon Schiele Archive, Gertrud Peschka-Schiele, and the late Melanie Schuster-Schiele.

73a. Engagement photograph of Schiele's parents: Adolf (1850–1905) and Marie Soukup (1862–1935)—Schiele, December 1877.

73b. Dress parade at the Tulln railroad station, honoring Adolf Schiele's 25th year of service, 12 September 1898: third from left, Adolf; eighth from left, Marie with daughter Melanie.

74a. Melanie, Marie, Egon, and Elvira Schiele, 1890.

74a. Egon at the age of one year, 1891.

74c. Adolf Schiele with his son Egon at the Vienna Prater, c. 1892.

75a. Egon holding his favorite locomotive and displaying a rare smile, c. 1894.

75b. Train drawings by Egon, c. 1898–1900. Collection Gertrud Peschka-Schiele and Anton Peschka, Jr., Vienna.

76a. Melanie, Egon, and Elvira Schiele, c. 1892.

76b. Melanie, Gerti, and Egon Schiele, 1894.

77a. Egon, c. 1898.

77b. Gerti, Melanie, and Egon Schiele, c. 1903.

77c. Last photograph of Adolf Schiele, with Gerti, c. 1904.

78a. Egon and his new pocket watch, posing for the family camera, 31 December 1903.

78b. Egon with his ice skates and a forbidden cigarette, Klosterneuburg, winter 1905.

79a. Egon as a first-year Academy student, fall 1906.

79b. Drawing triangle used by Egon at the Academy. Formerly Collection Melanie Schuster-Schiele, Vienna.

80a. Egon clowning behind his uncle Czihaczek's back, 15 July 1908.

80b. Egon and Uncle Czihaczek in a haystack, 15 July 1908.

81a. Schiele's mother, c. 1907.

81b. Egon Schiele at the age of nineteen, 1909.

82a. Melanie Schiele, c. 1911.

82b. Melanie Schiele standing before her brother's mirror, 1963.

83a. Gerti Schiele, c. 1911.

83b. Gerti Schiele as a *Wiener Werkstätte* fashion model, c. 1911.

84a. Egon Schiele, 1914.

84b. Gerti Schiele, c. 1911.

84c. Melanie Schiele, c. 1911.

85a. Egon Schiele and Arthur Roessler, 1913.

85b. Egon Schiele and Walli Neuzil, 1913.

85c. Egon Schiele, 1913.

86a. The Harms family, c. 1914: second from left, Edith; fourth from left, Adele.

86b. Letter written 10 December 1914 by Egon Schiele inviting "Edith and Adele, or Adele and Edith" Harms to attend the movies with him and "chaperone" Walli.

87a. Edith Schiele (—Harms), c. 1917.

87b. Edith Harms's note agreeing to a secret rendezvous with Schiele, early 1915.

88a. Adele Harms photographed by Egon Schiele, c. 1917.

88b. Adele Harms photographed by Egon Schiele, c. 1917.

89a. Edith and Egon Schiele with nephew Paul Erdmann, 1915.

89b. Edith and Egon Schiele, 1915.

89c. Wedding announcement of Edith and Egon Schiele, 17 June 1915.

90a. Atelier photograph of Schiele's painting *The Hermits* (K. 159, 1912) (placed upside down for camera image) with Edith standing in right background. Left background shows the painting *House with Drying Laundry* (K. 229, 1917) in its first version.

90b. Edith Schiele with two unidentified army comrades of Egon, c. 1916.

91a. Egon Schiele as a soldier, c. 1916.

91b. Egon Schiele with an army comrade, c. 1916.

91c. Egon Schiele (top row, second from left) with his army platoon, c. 1916.

92a. The artist looking at himself in his mirror, 1916.

92b. Egon Schiele seated in a chair made by himself, 1916.

92c. Unsigned pejorative newspaper review of Schiele's work, *Österreichische Volkszeitung*, 2 November 1917. "That just in our day and age an artist exists whose name is Schiele ["schielen" = "to squint"] is probably no accident. He is still squinting at things which others already see. But squinting is exactly suitable to this particular artist."

93. Death-bed photograph of Egon Schiele, 1 November 1918.

94a. Funeral announcement for Edith Schiele, died 28 October 1918, with the annotation by Schiele's brother-in-law, Anton Peschka, reporting that "Egon extremely ill."

94b. Funeral announcement for Egon Schiele, died 31 October 1918.

95. Death mask of Egon Schiele.

The Plates

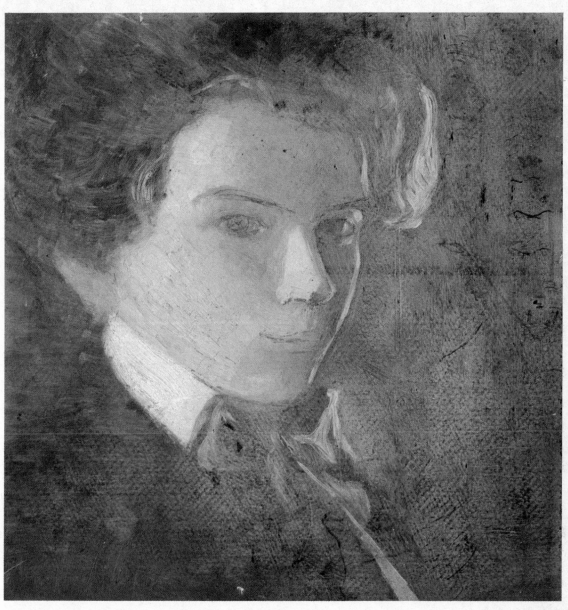

1

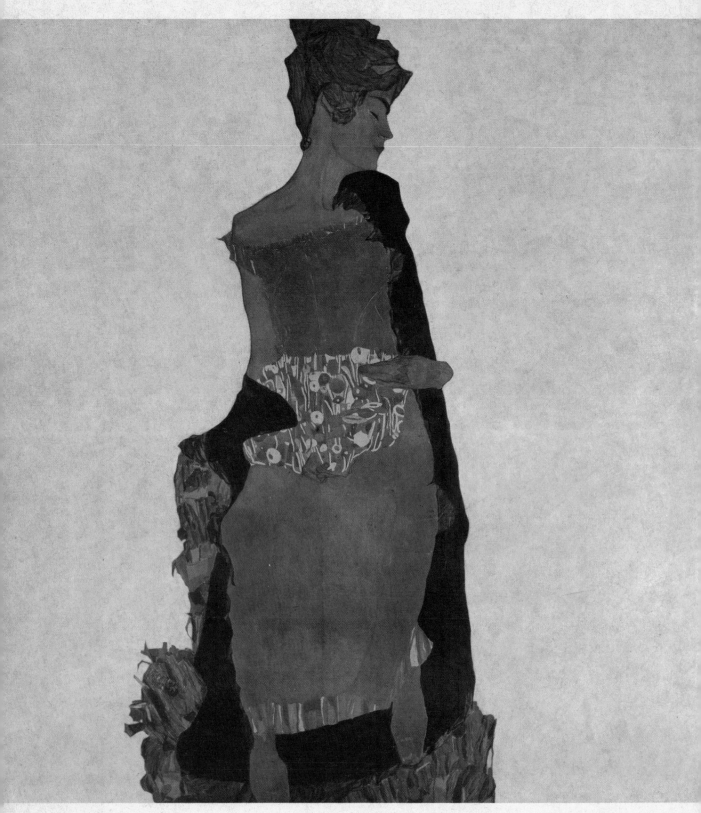

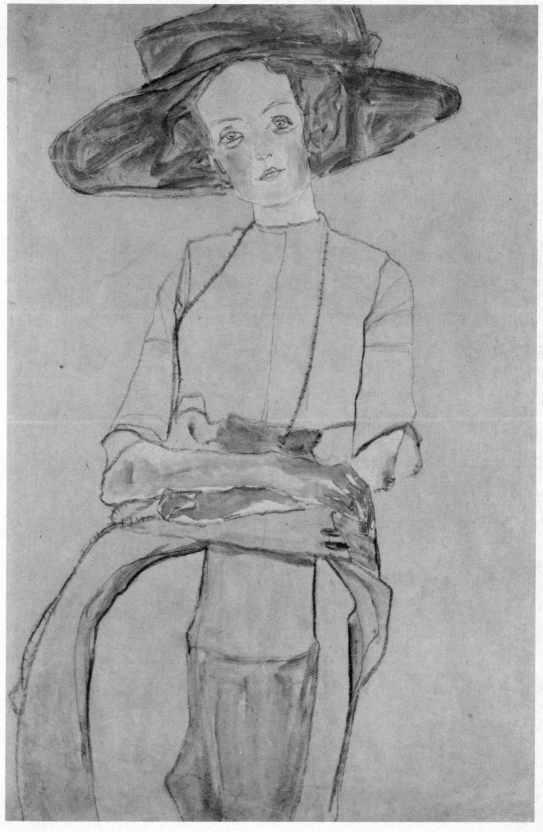

3

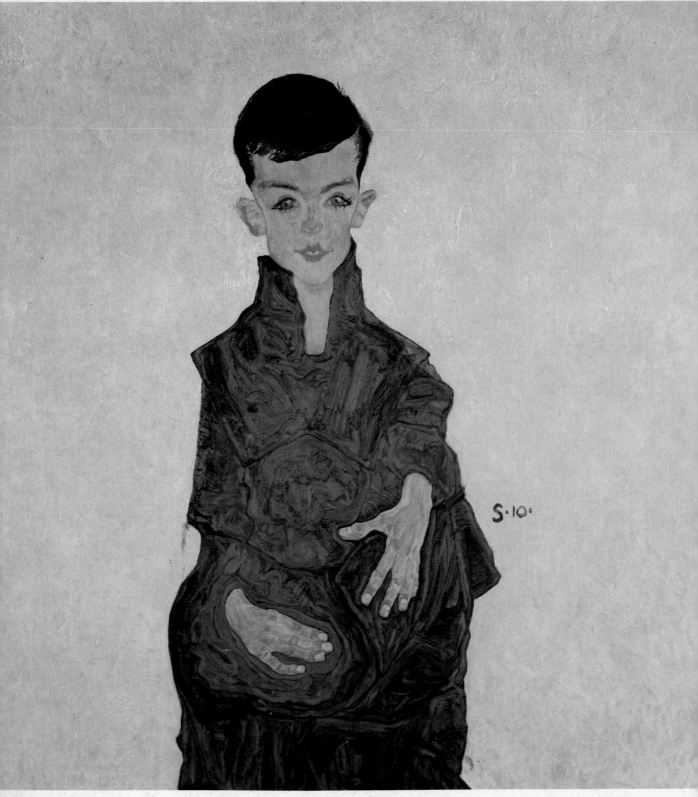

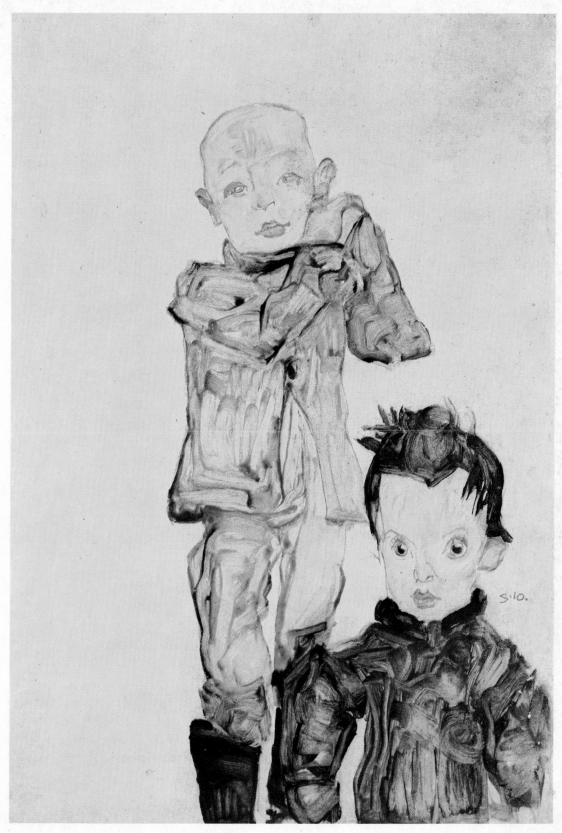

5

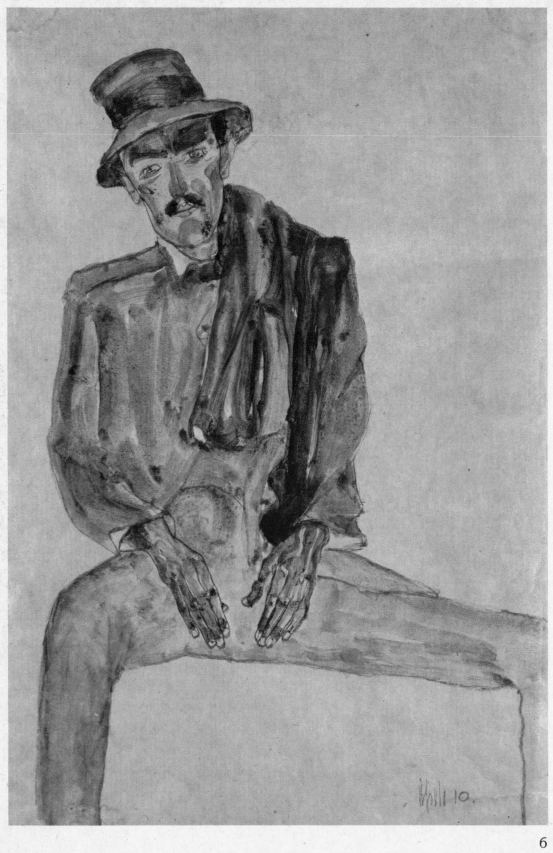

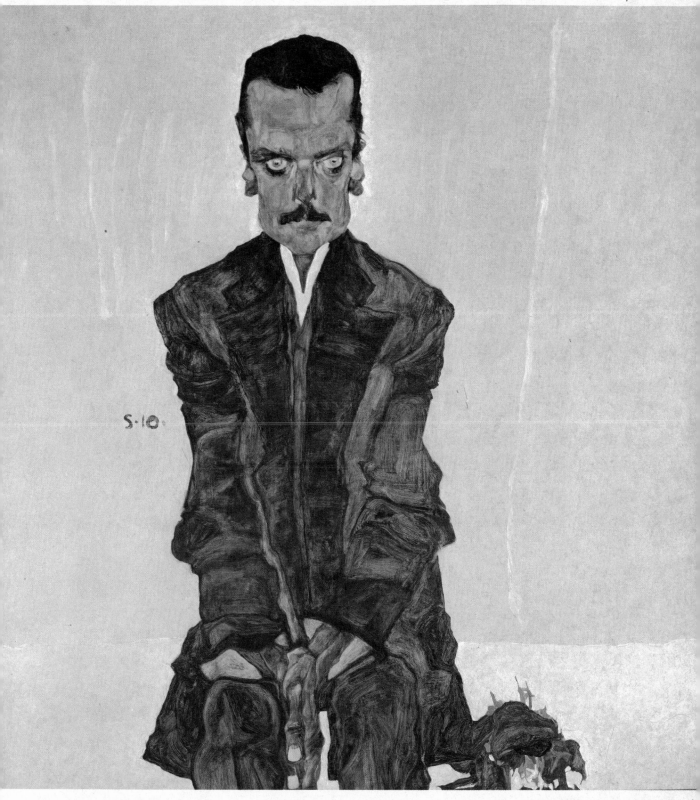

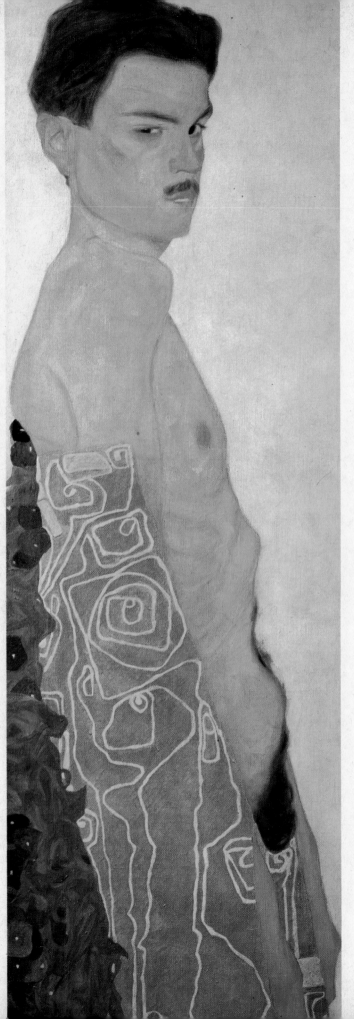

8

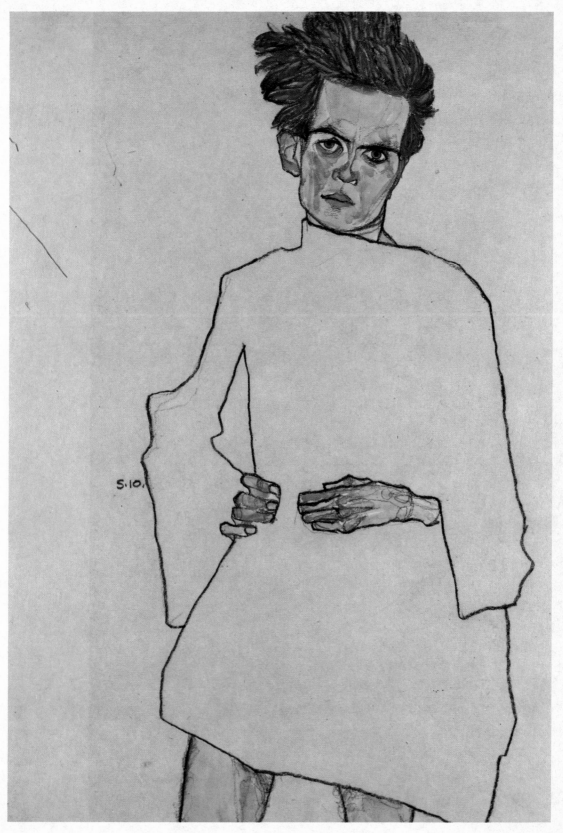

9

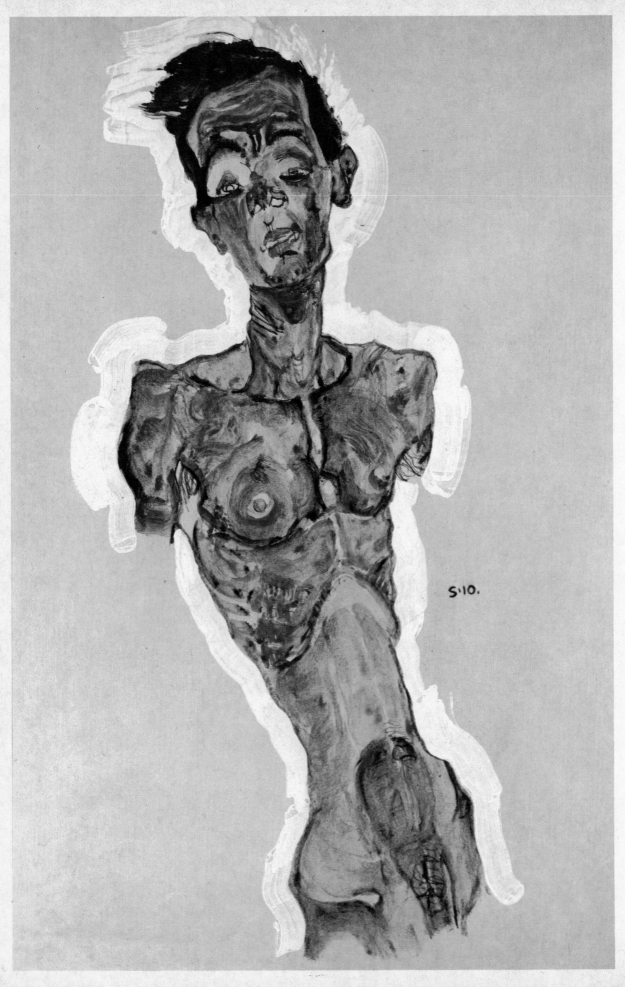

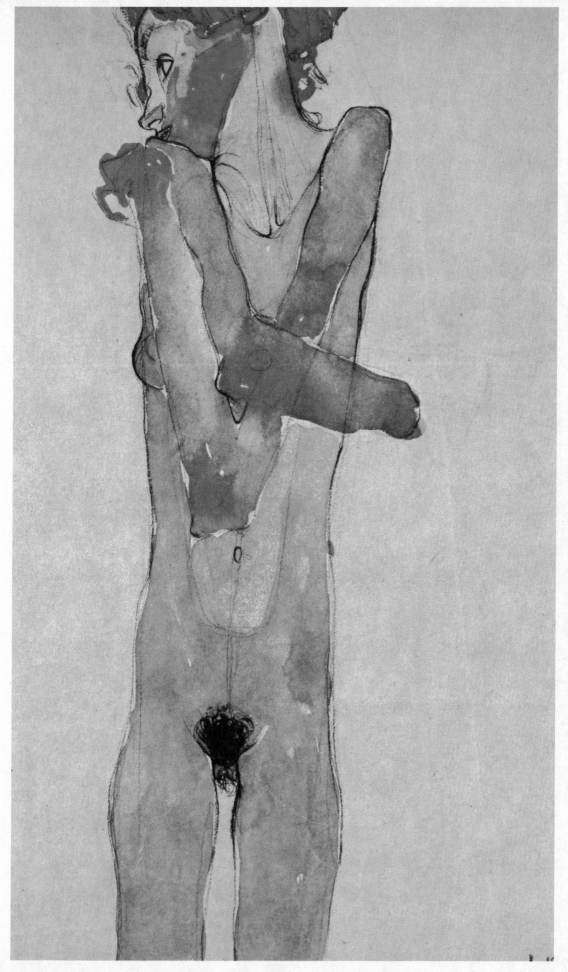

11

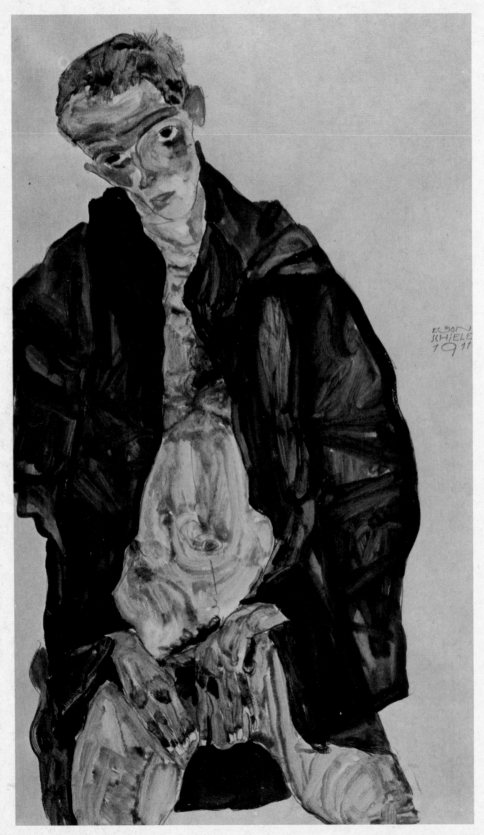

12

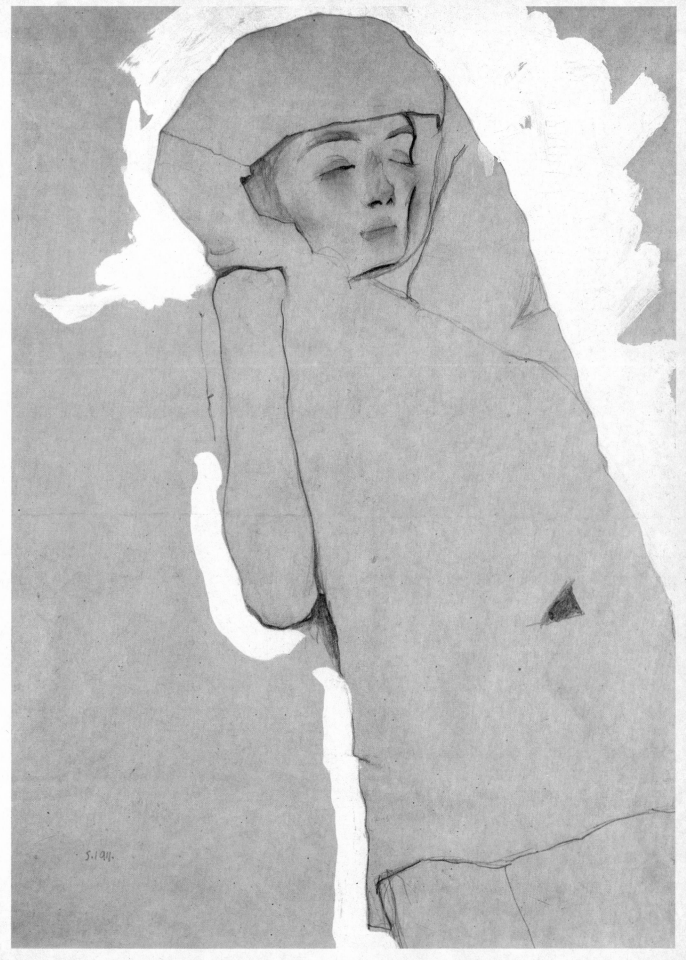

13

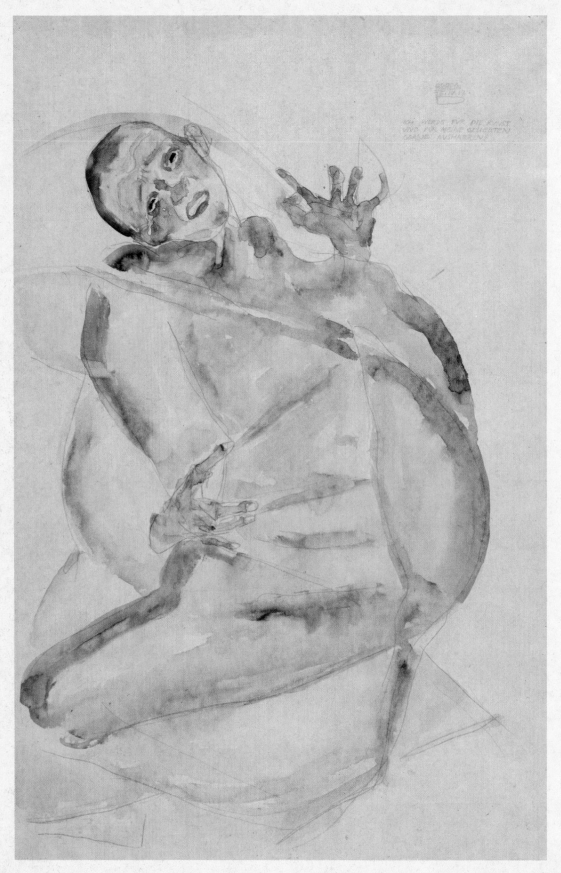

14

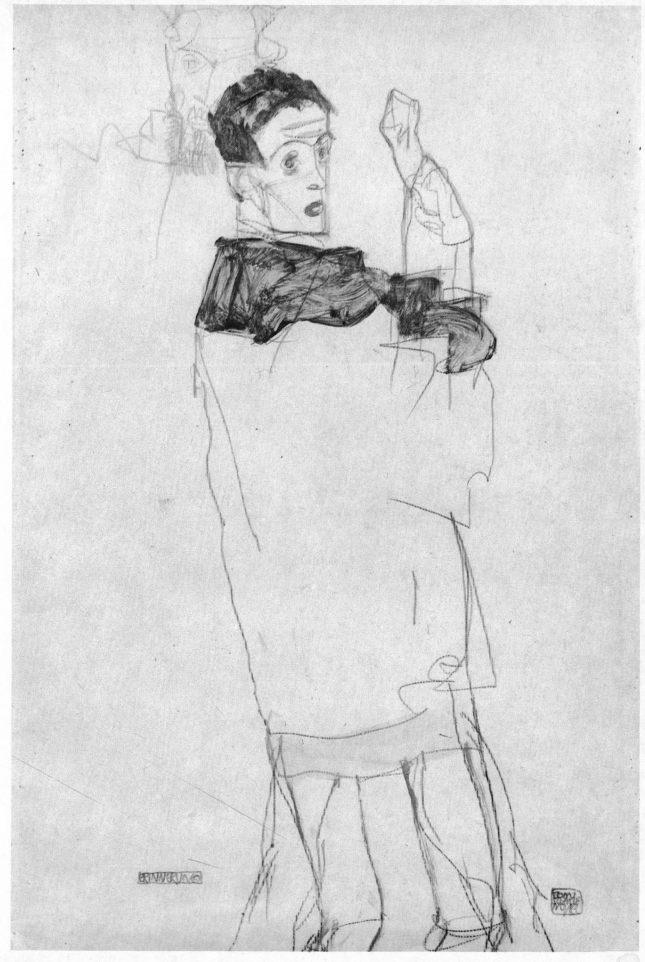

ERINNERUNG

15

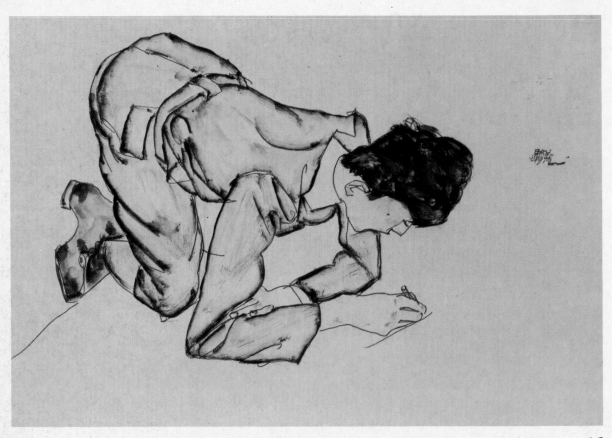

16

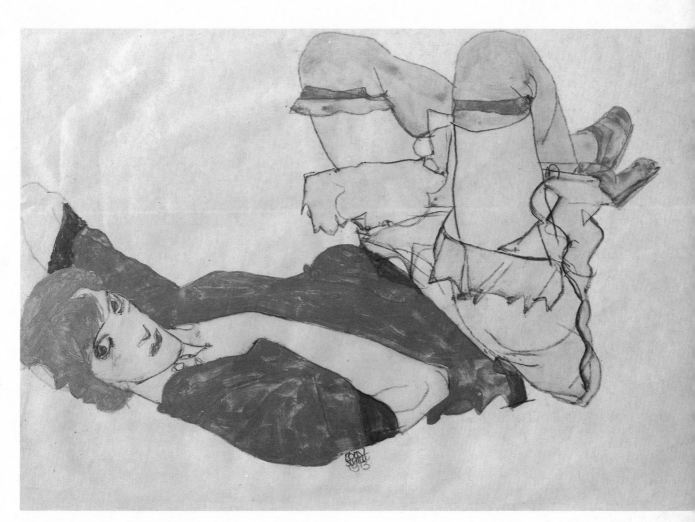

17

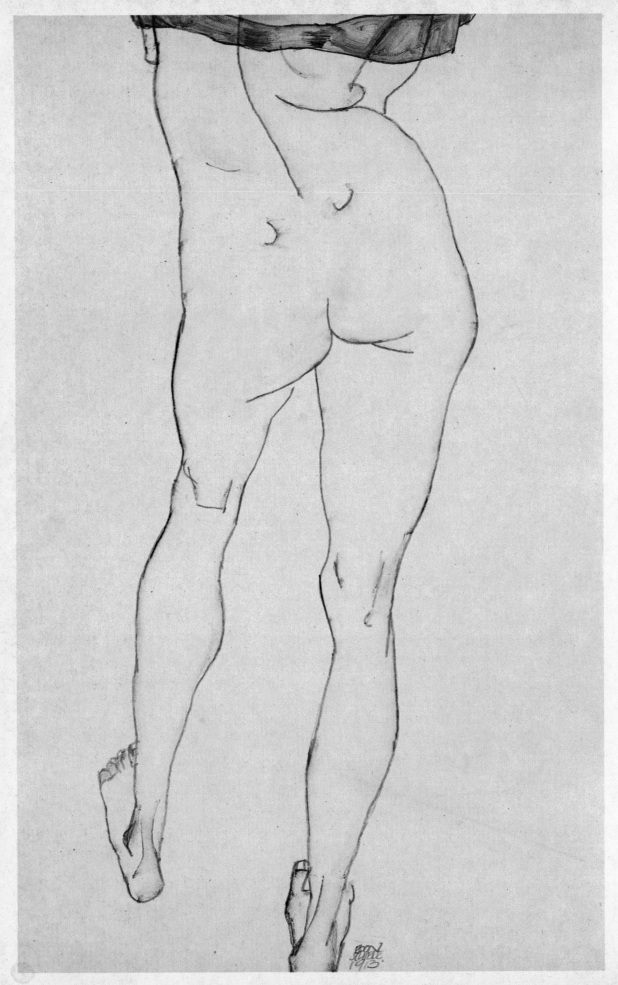

18

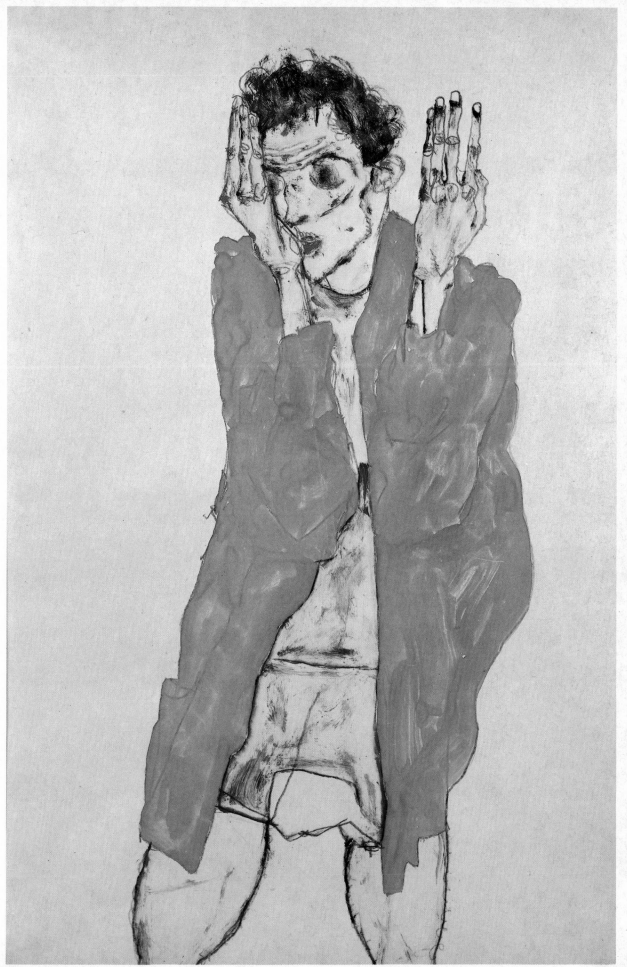

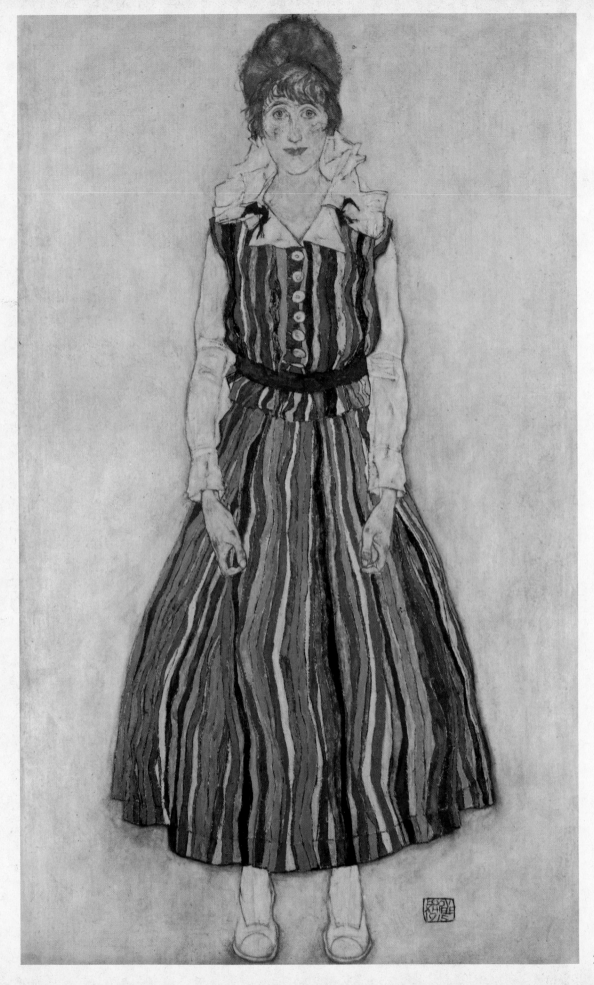

20

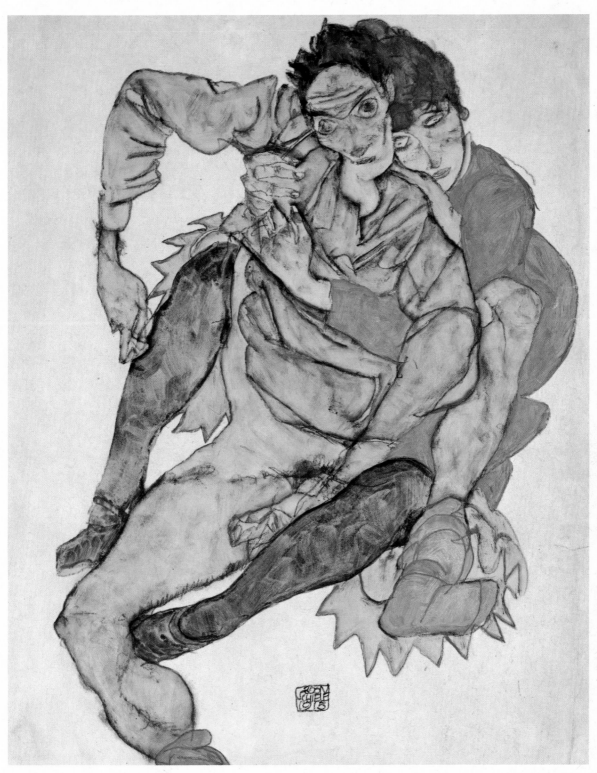

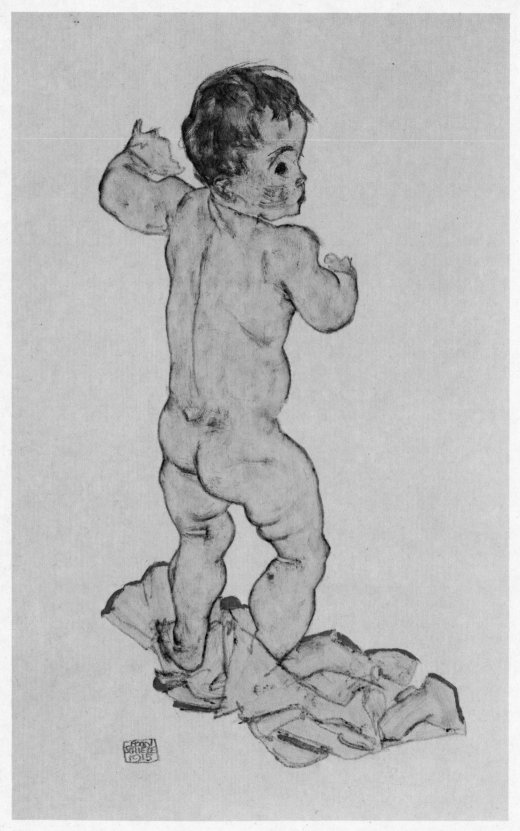

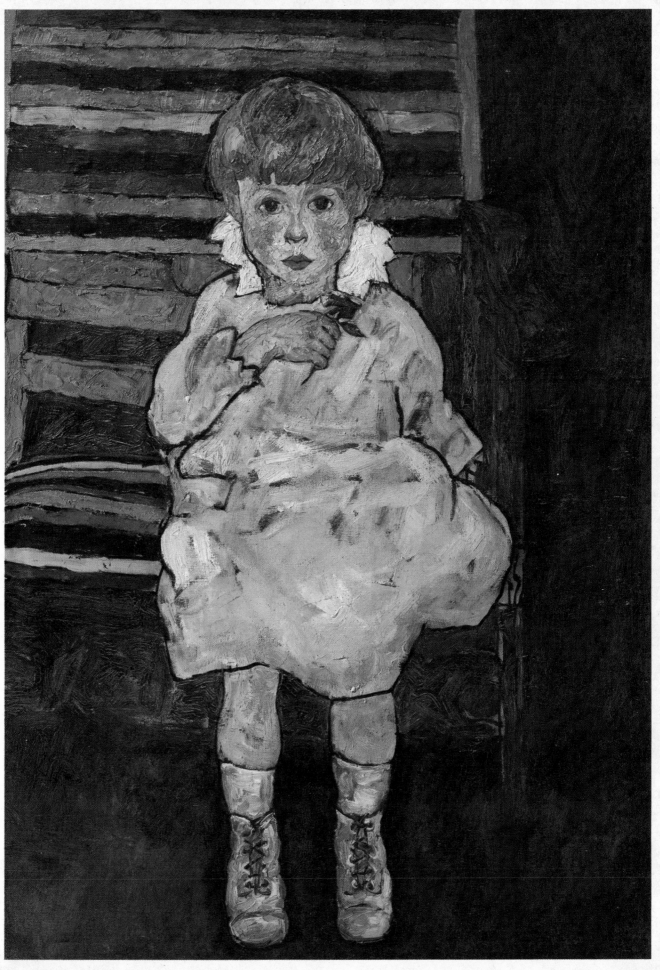

23

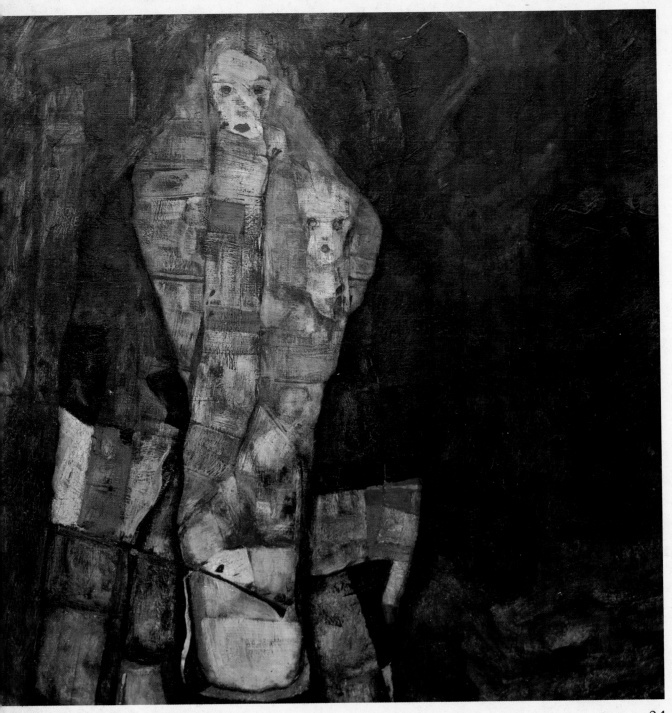

24

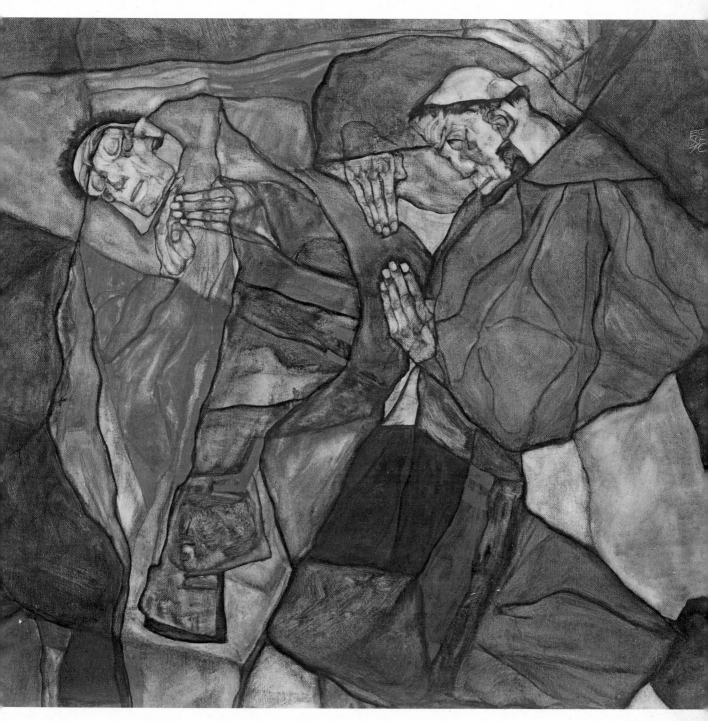

25

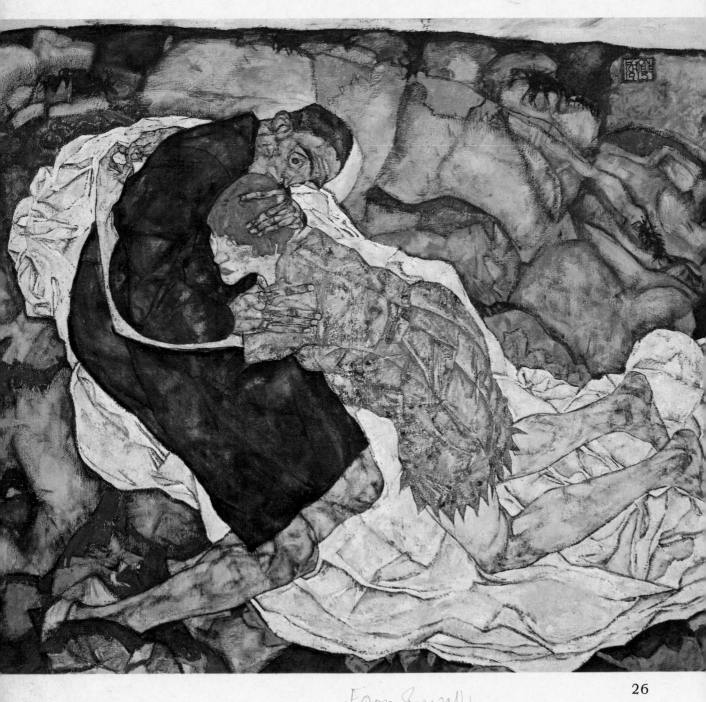

Egon & walli

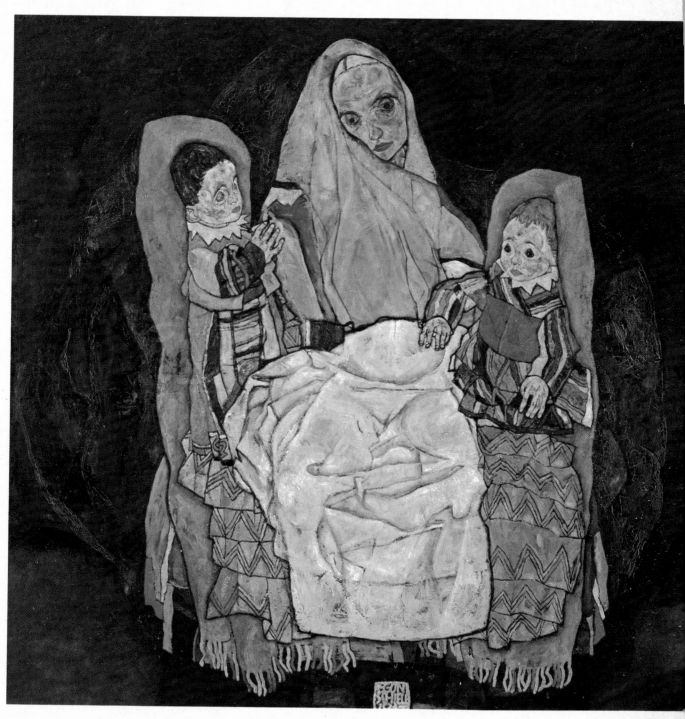

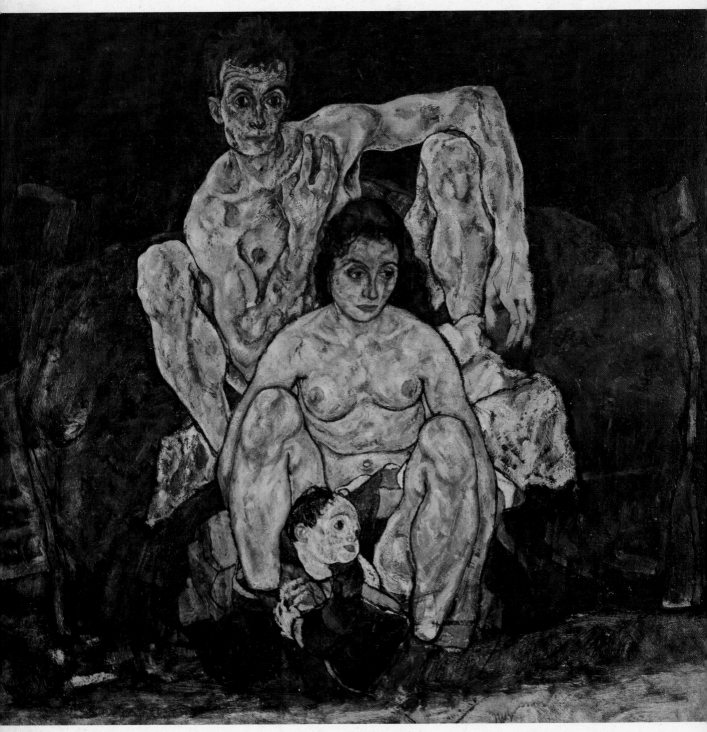

28

29

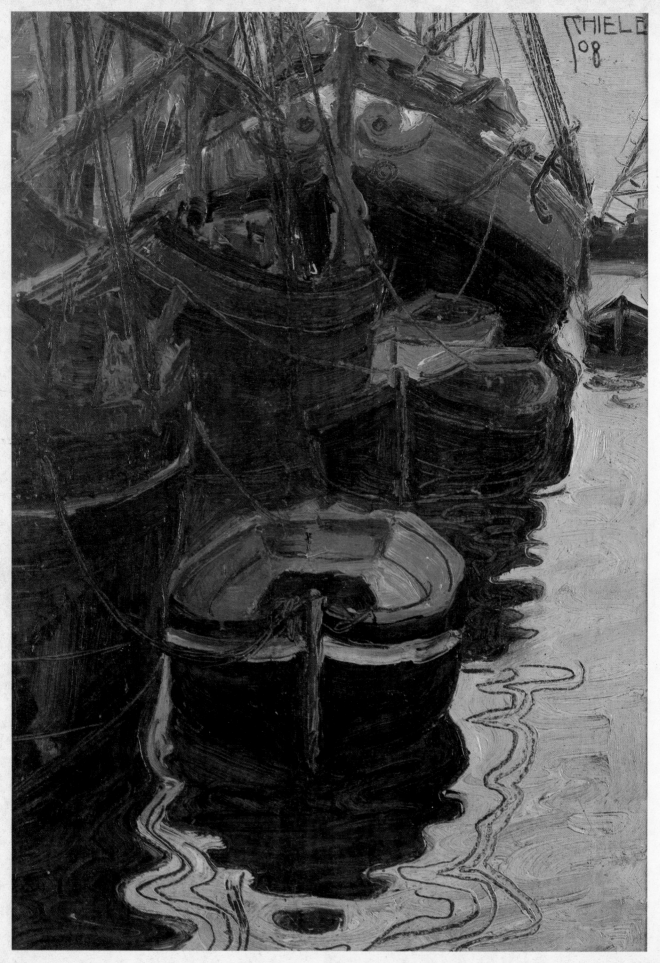

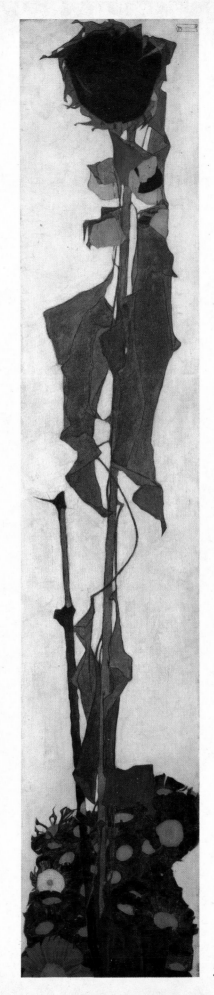

31

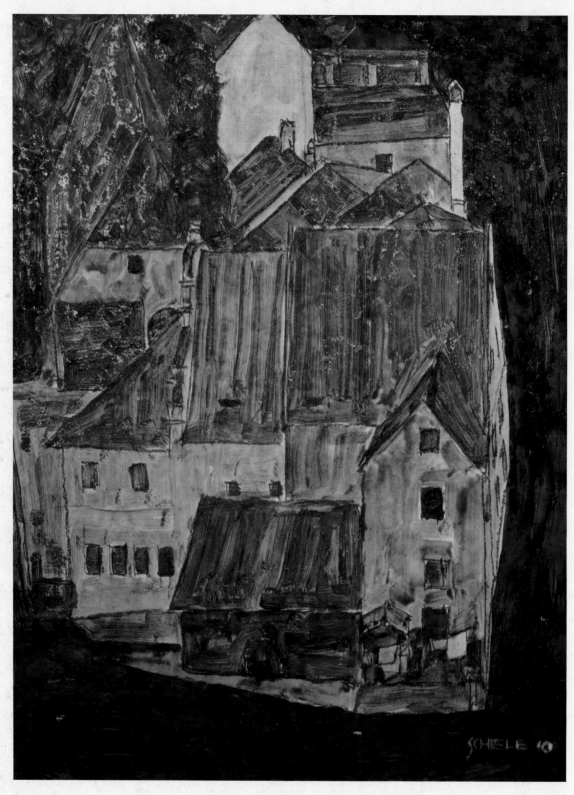

32

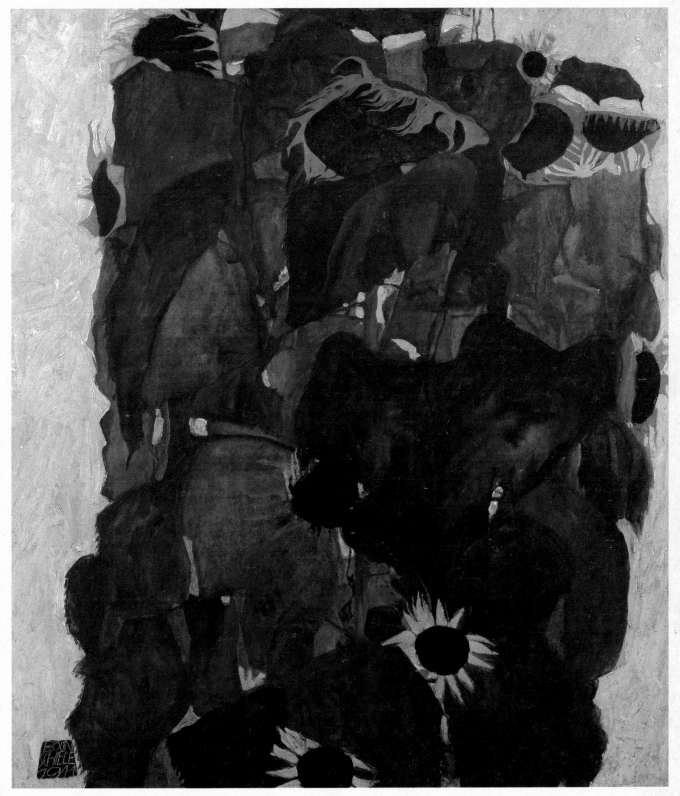

33

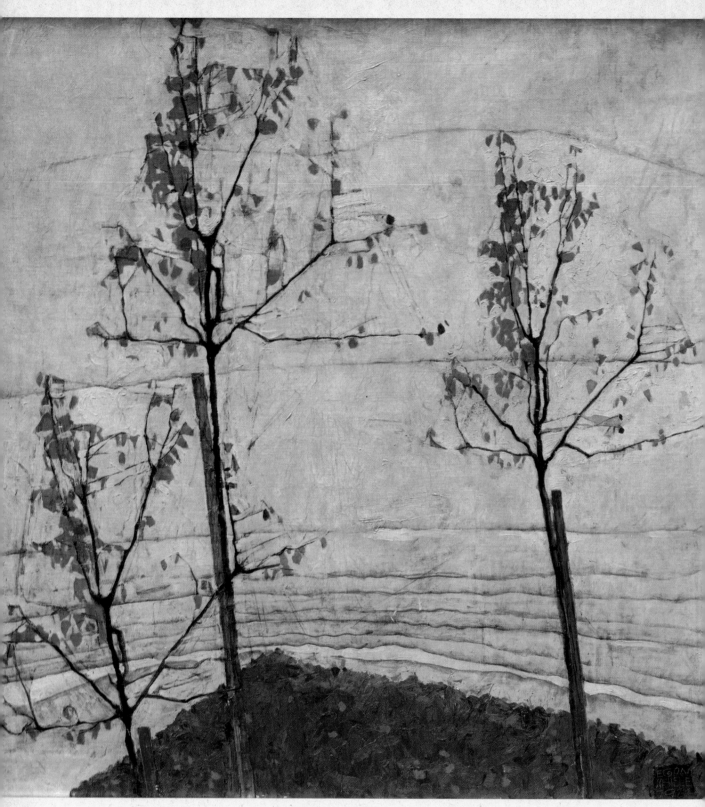

34

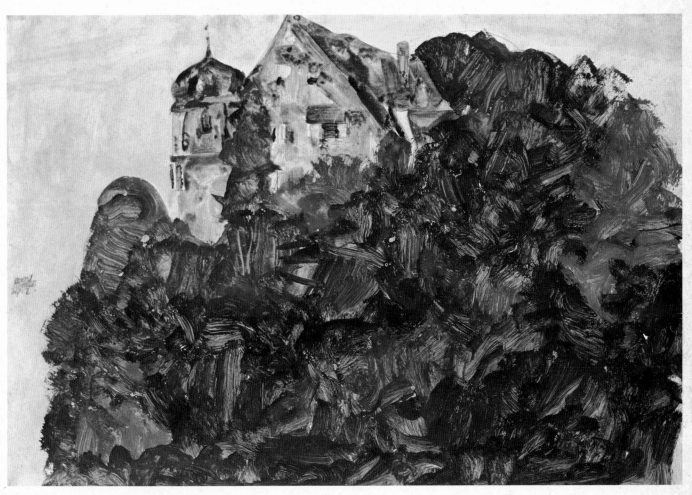

35

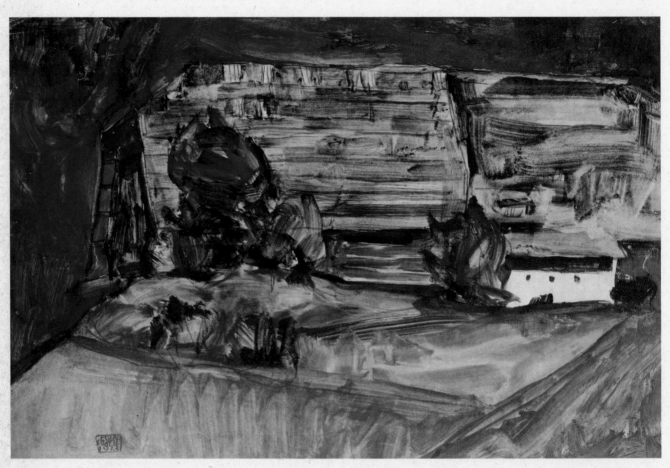

36

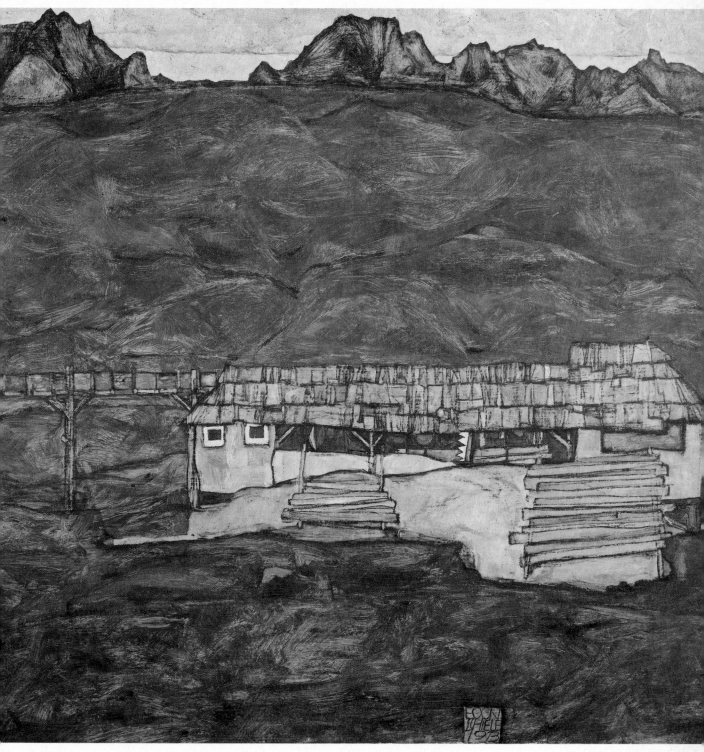

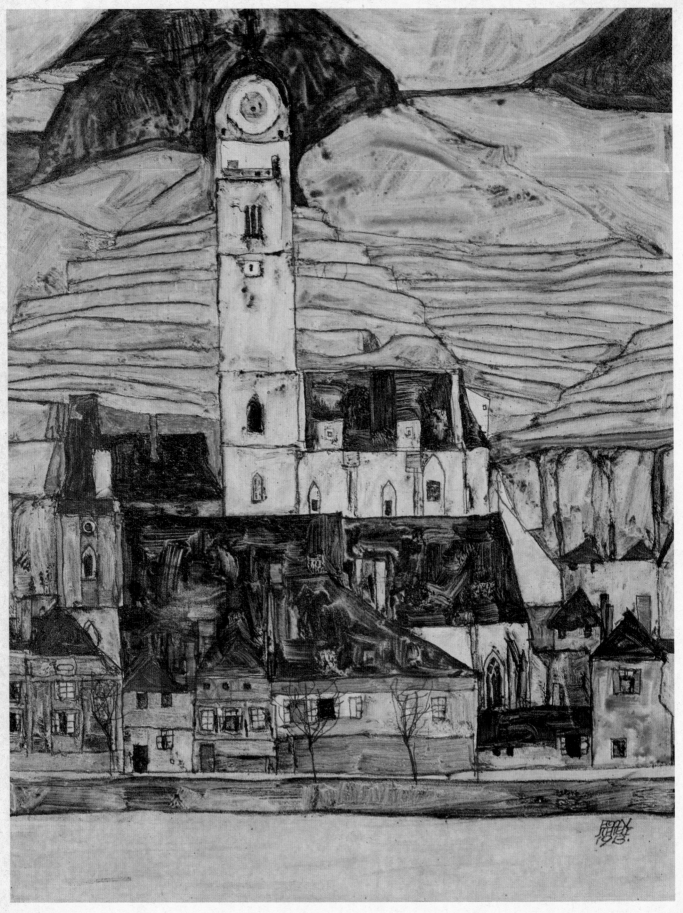

38

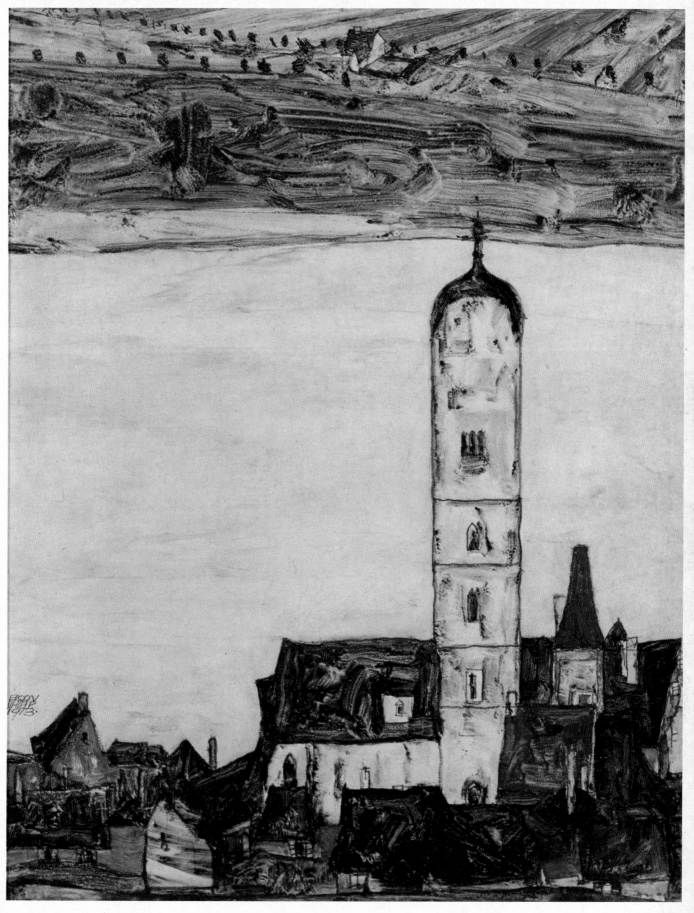

39

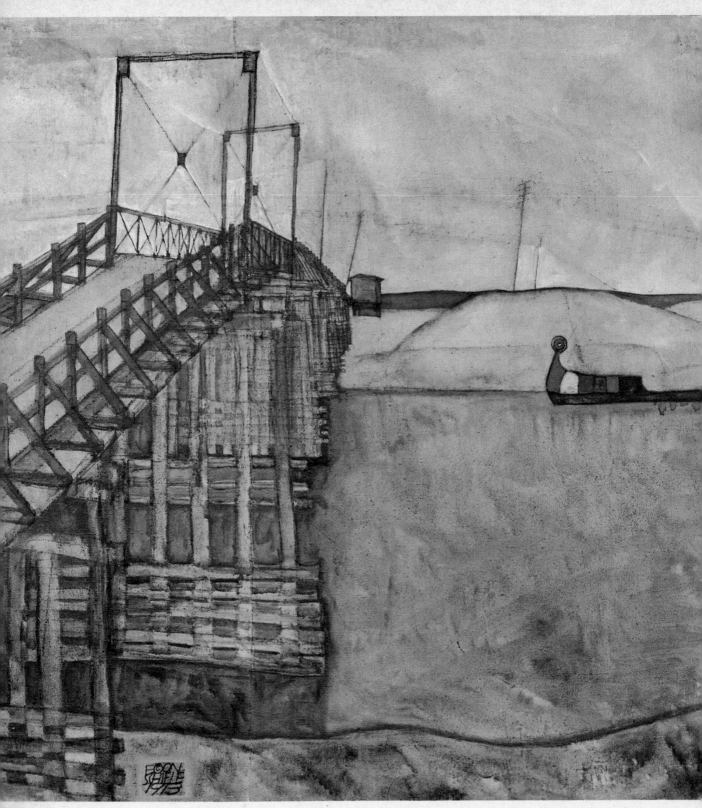

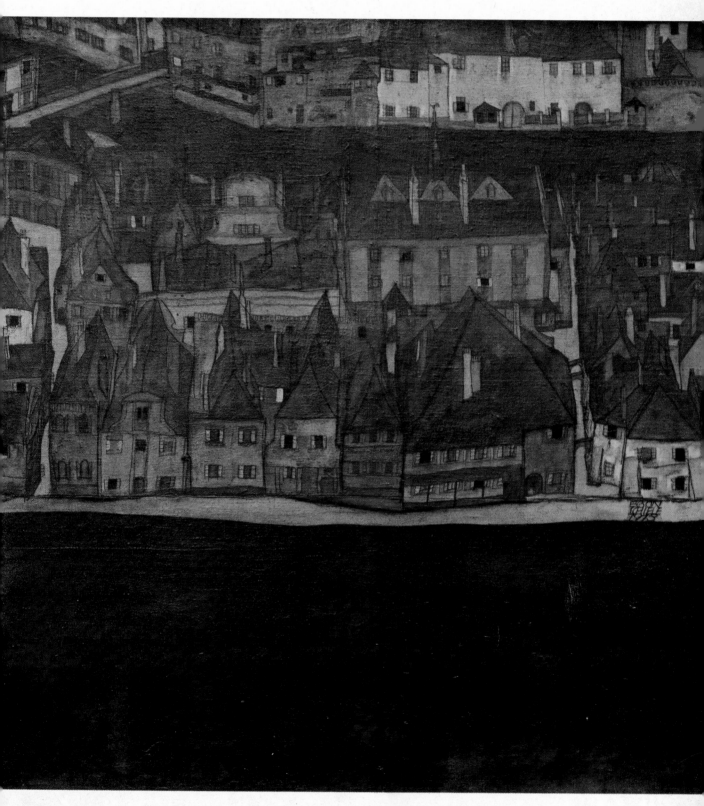

42

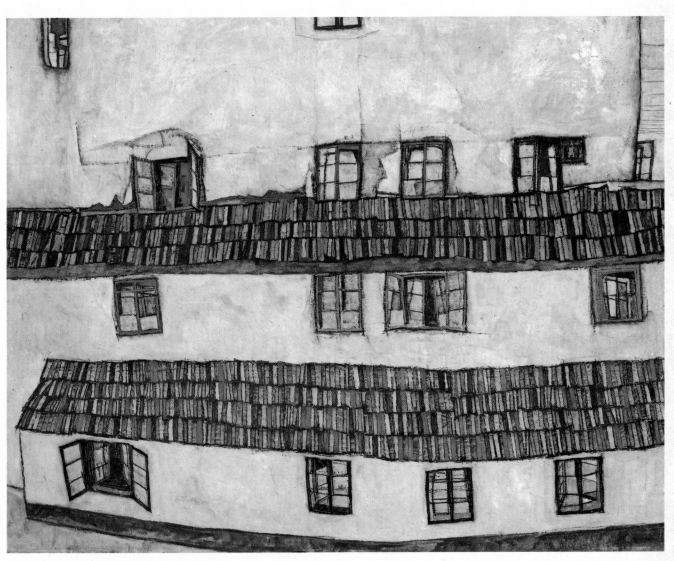

43

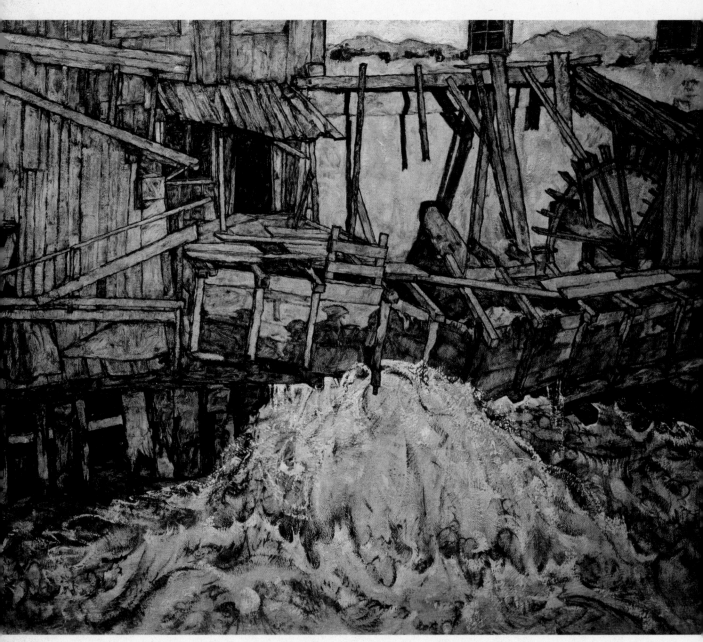

44

45

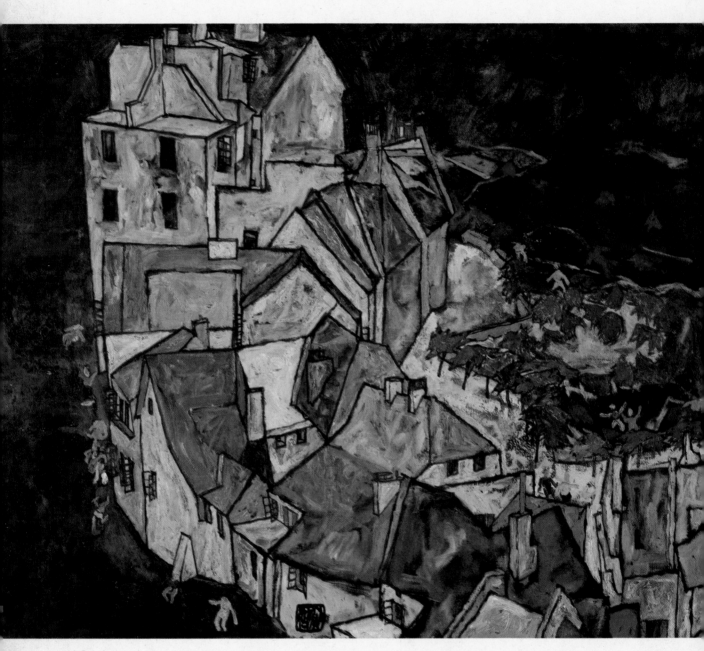

46

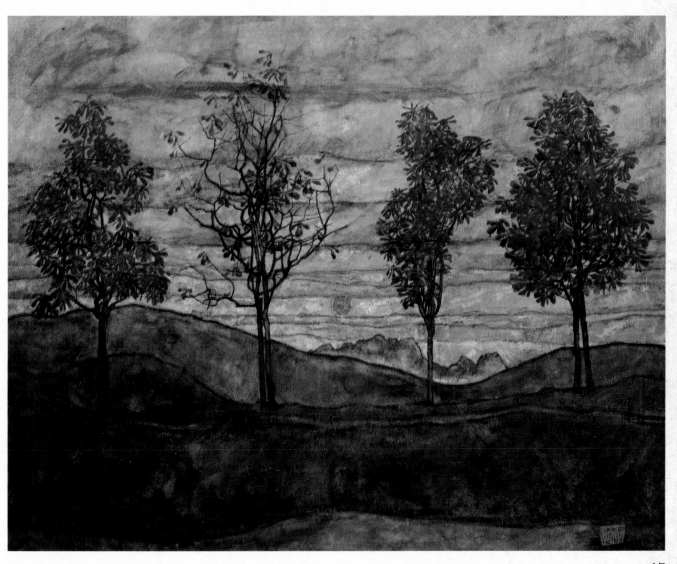

47

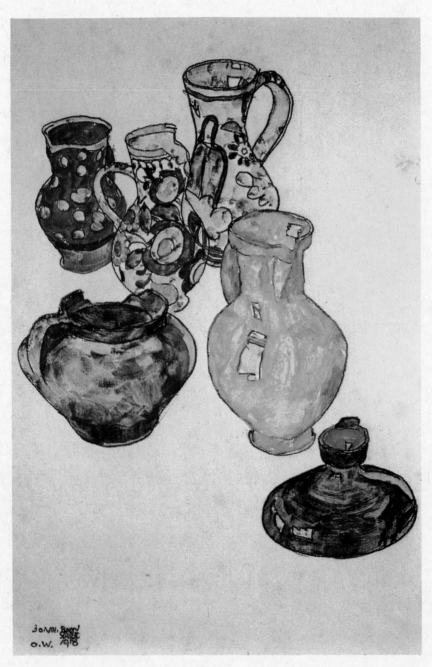

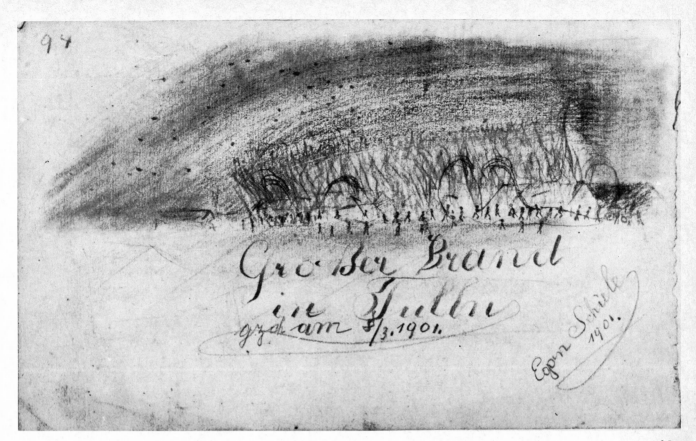

Großer Brand
in Tulln
gzd am 5/3.1901.

Egon Schiele
1901.

49a

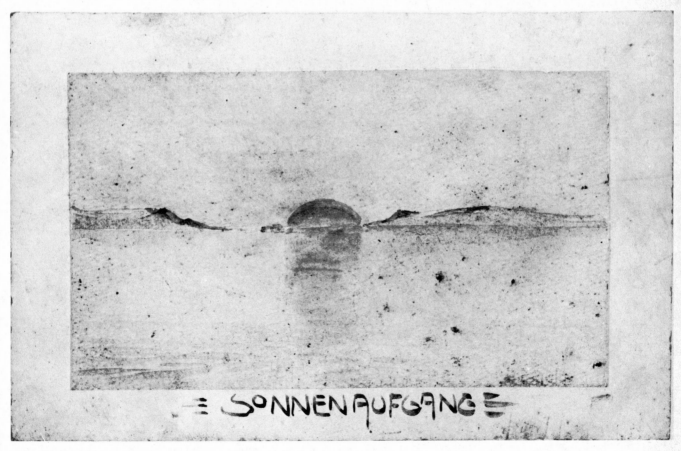

SONNENAUFGANG

49b

50a

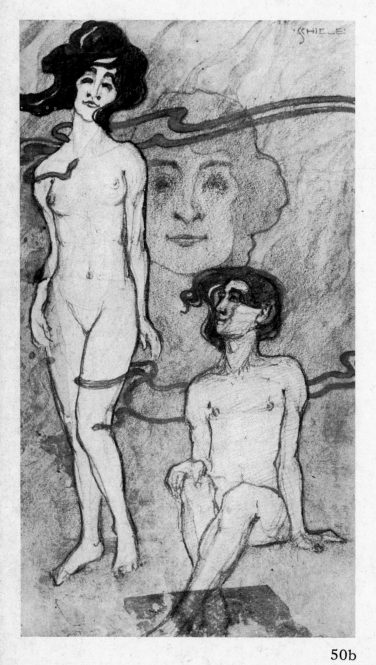

50c

50b

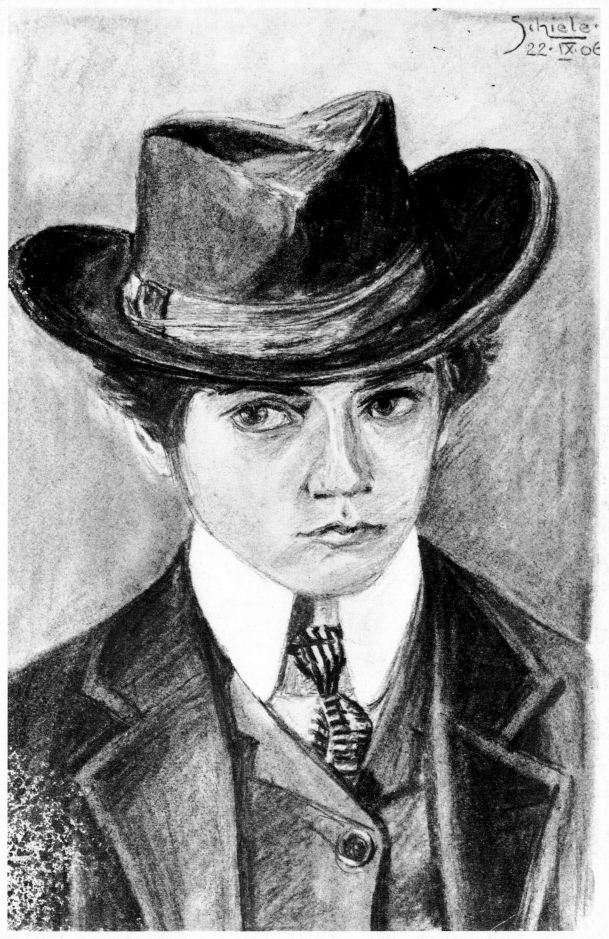

51

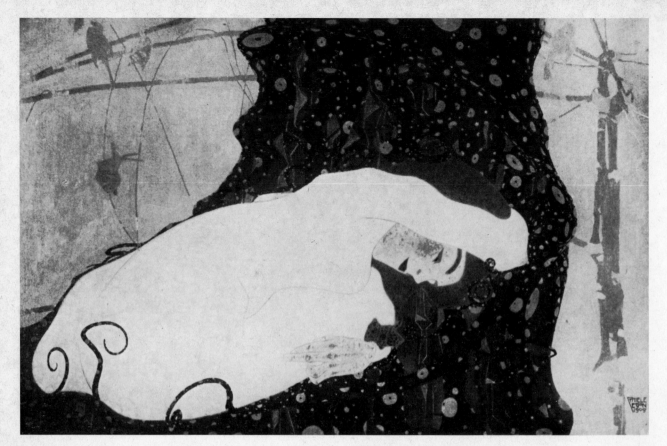

52a

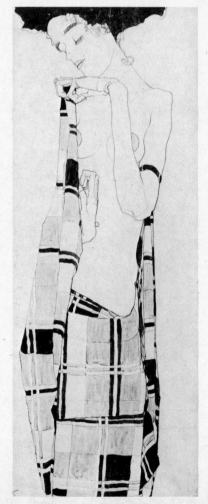

Gerti

52b

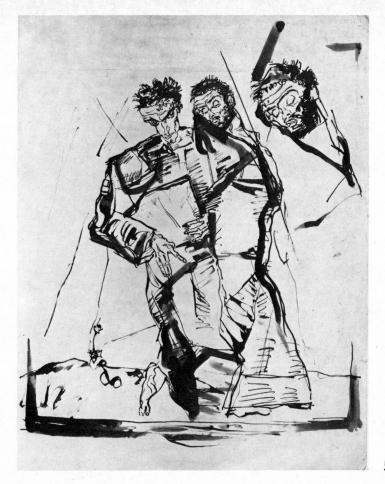

53a

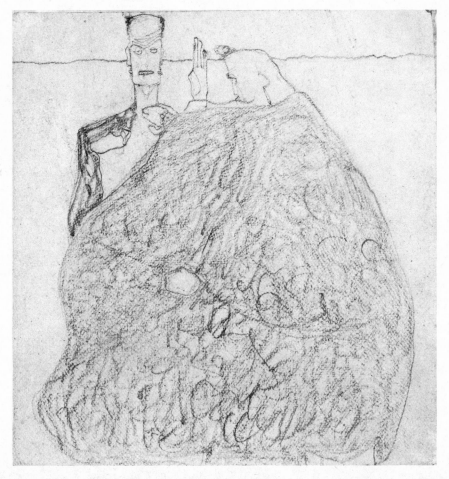

53b

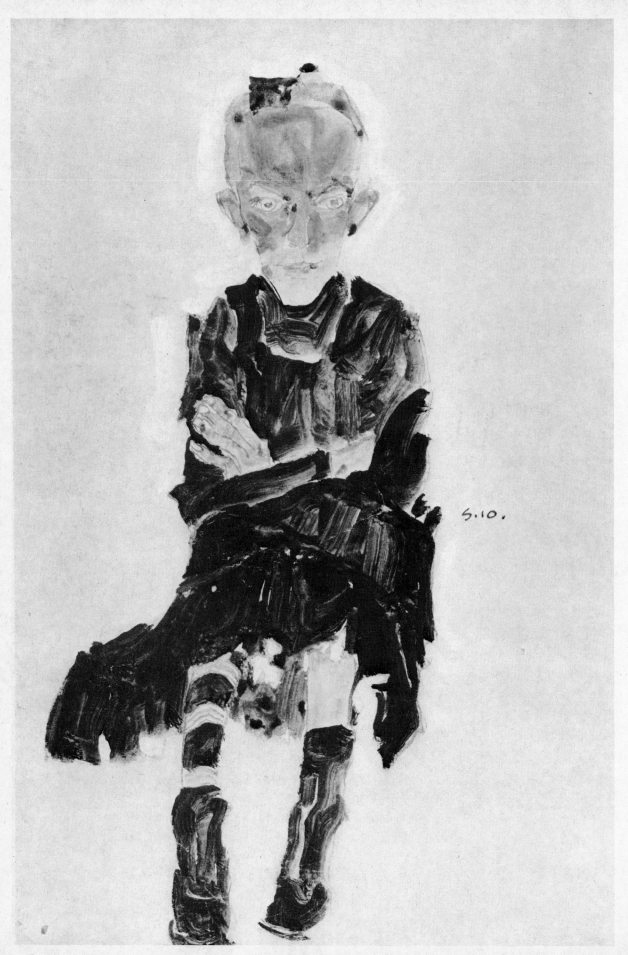

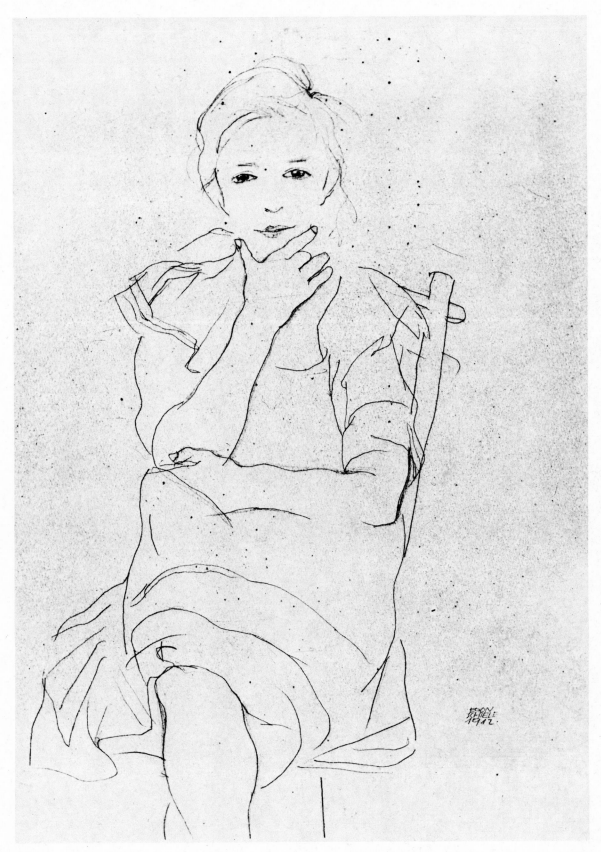

55

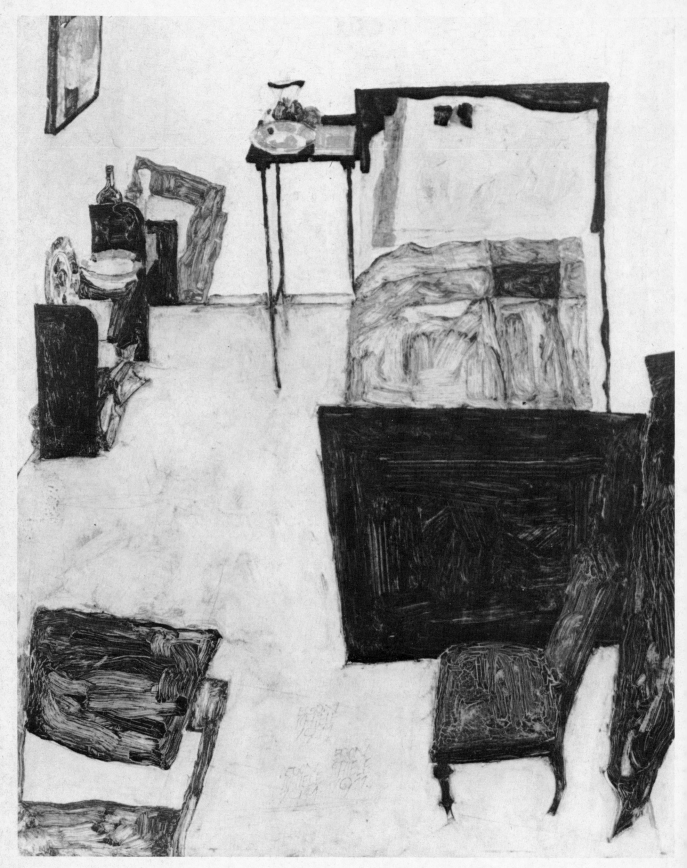

57

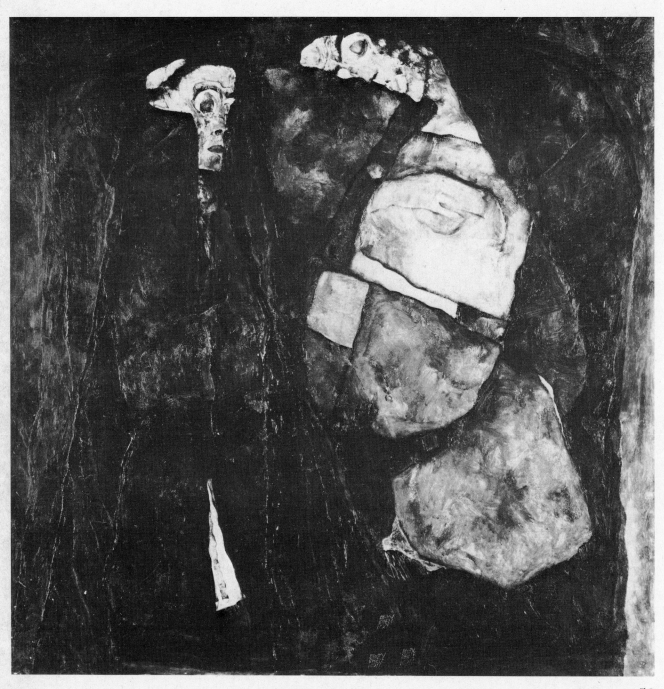

58

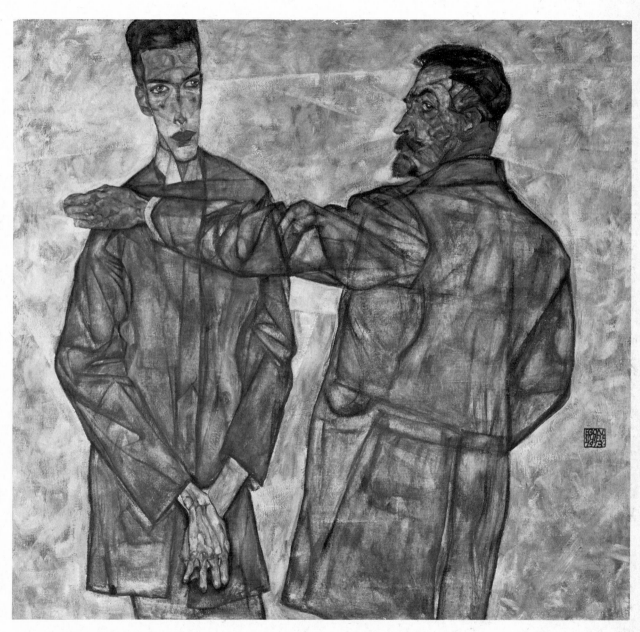

59

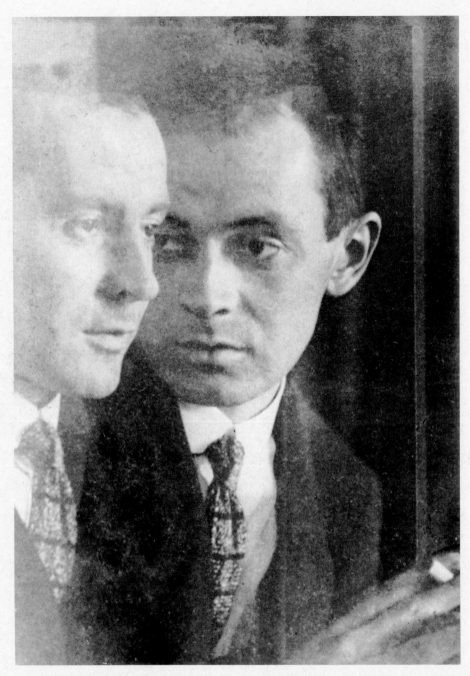

60

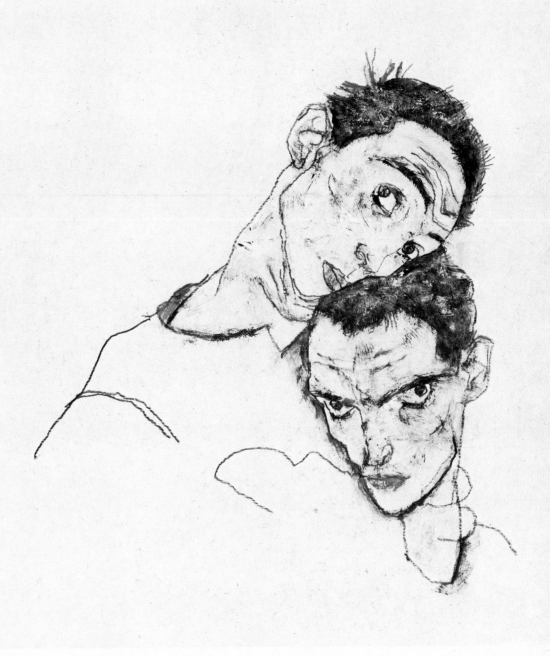

61

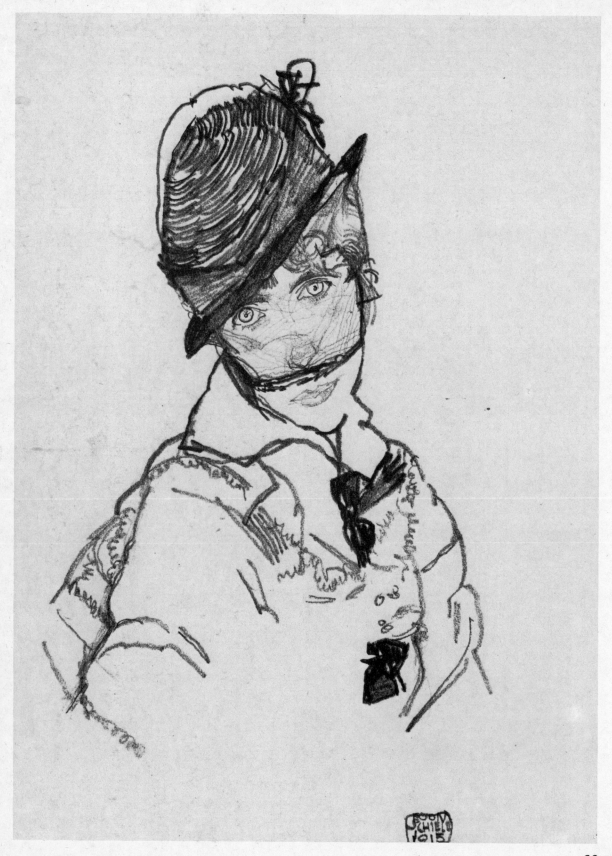

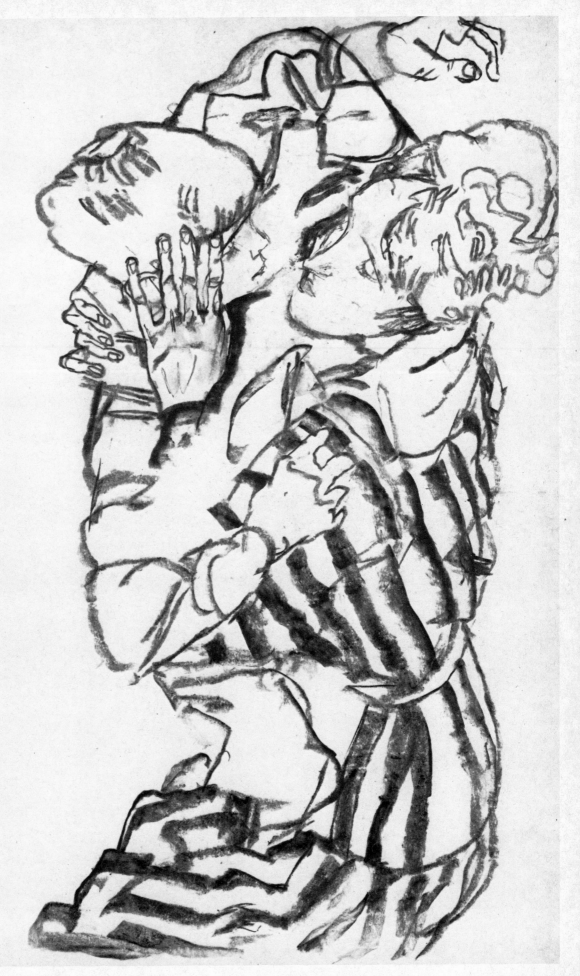

63

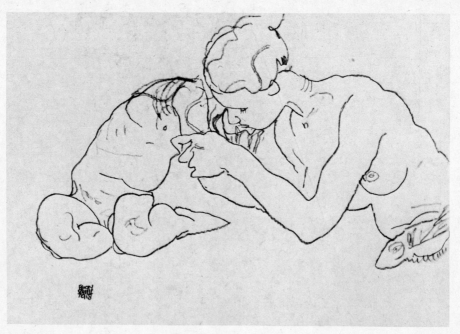

64a

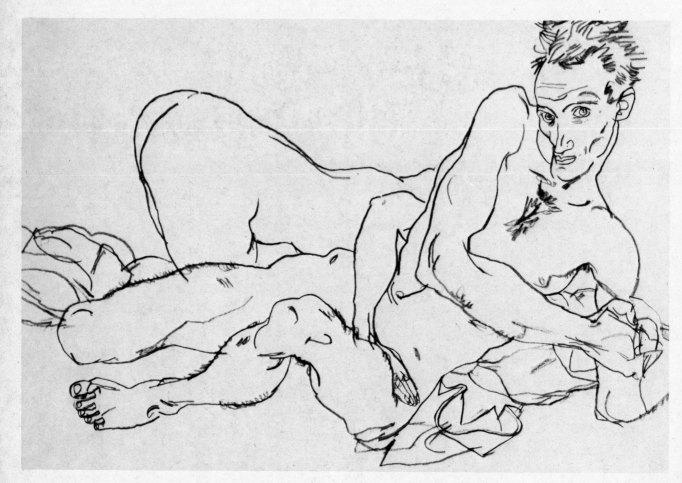

64b

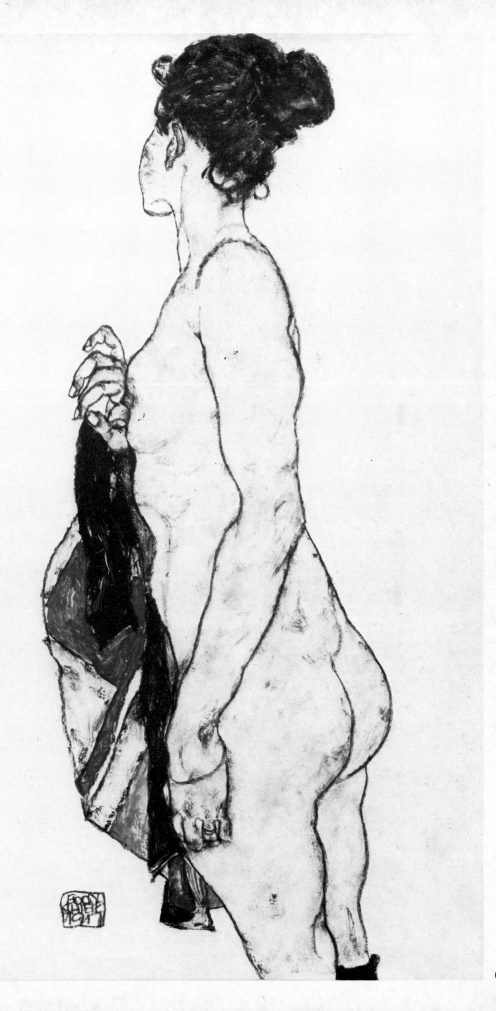

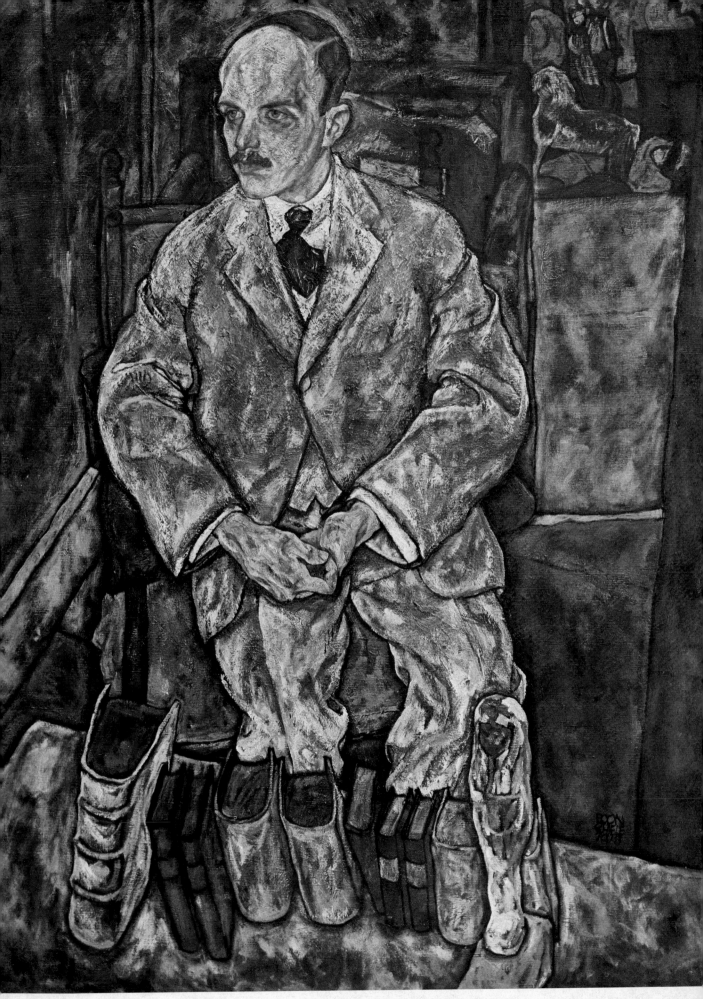

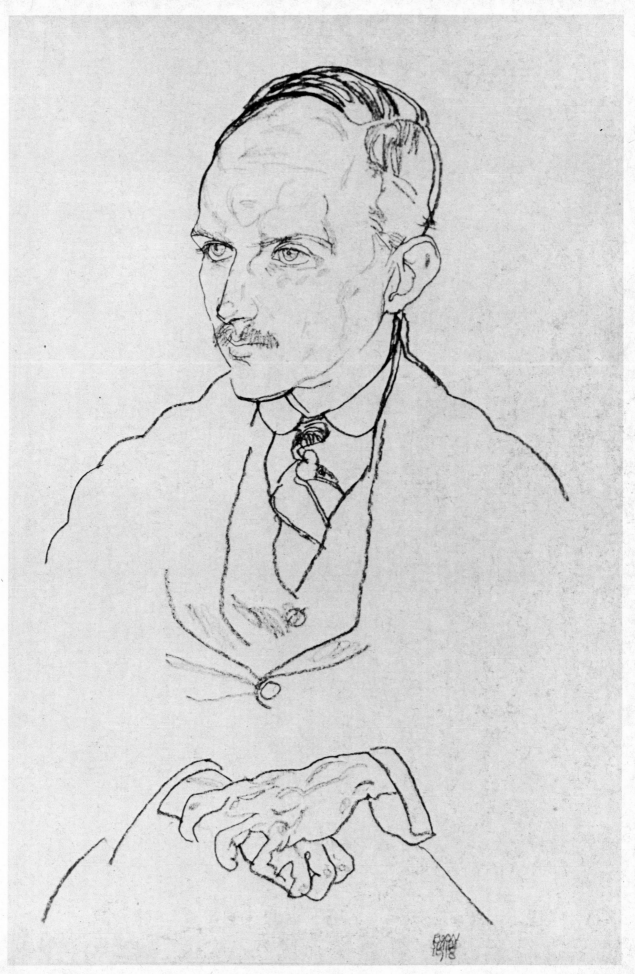

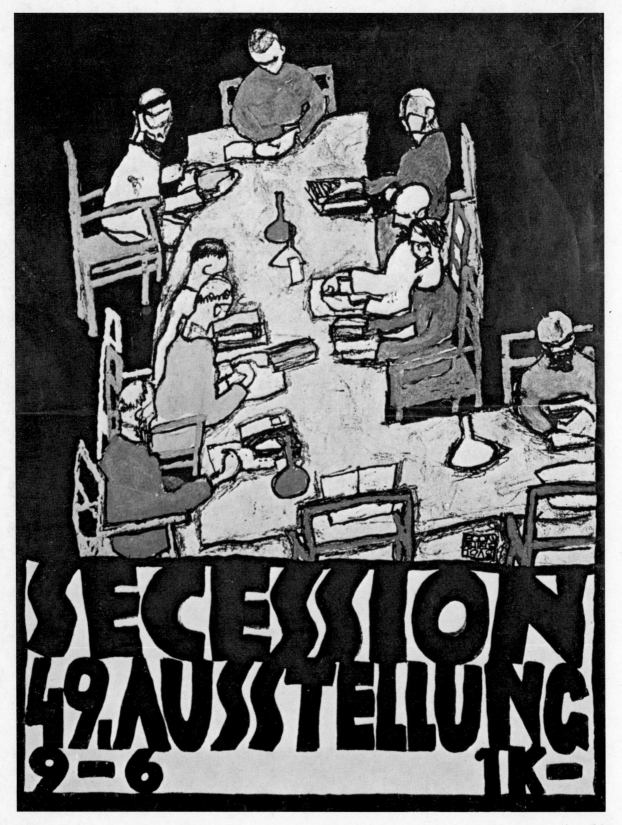

69a

69b

70a

70b

70c

71a

71b

71c

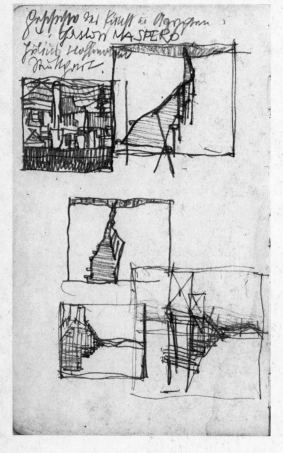

72a

72c

72b

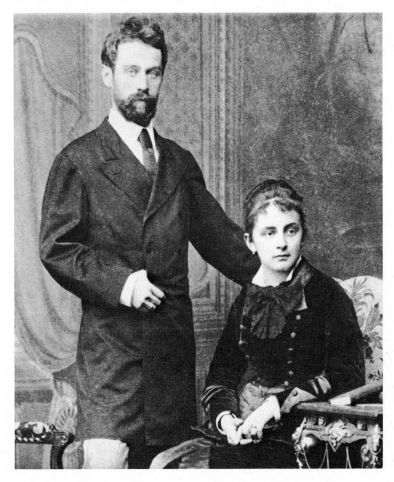

73a

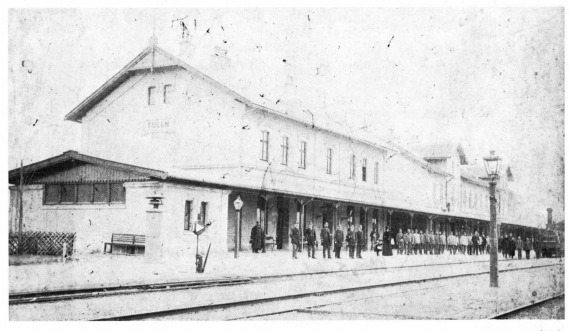

73b

74a

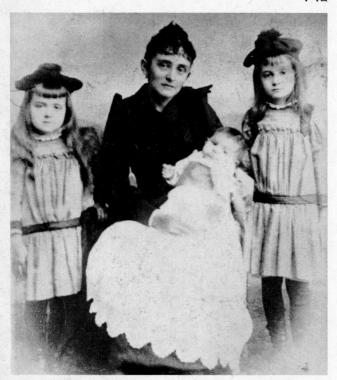

74b

74c

75b

75a

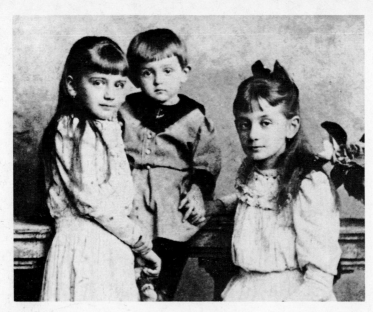

76a

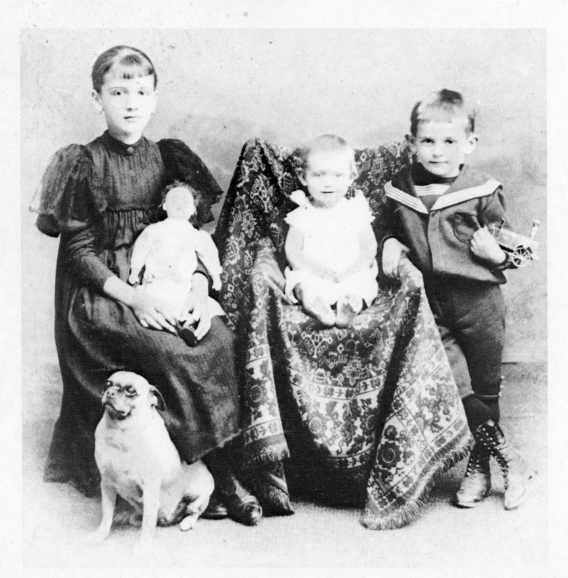

76b

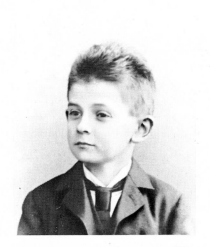

77a

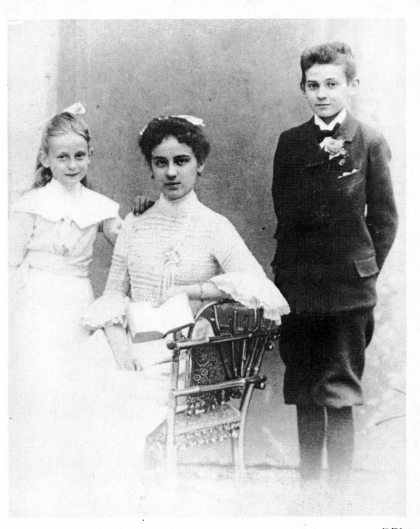

77b

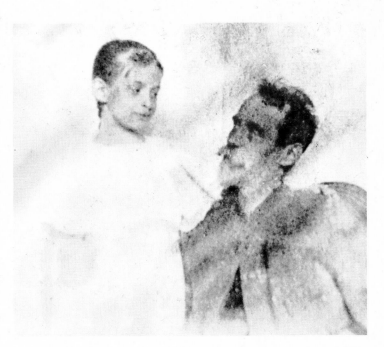

77c

78a

78b

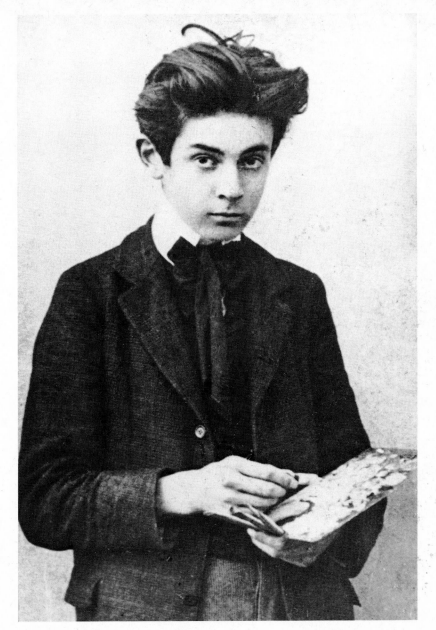

79a

79b

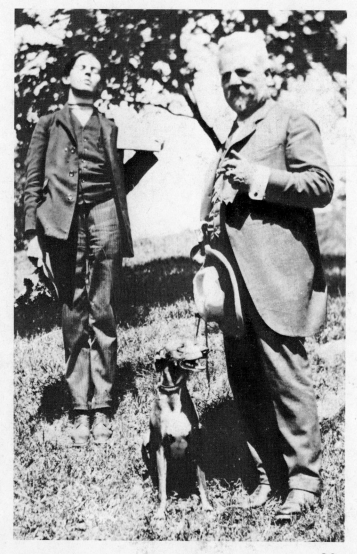

80a

80b

81a

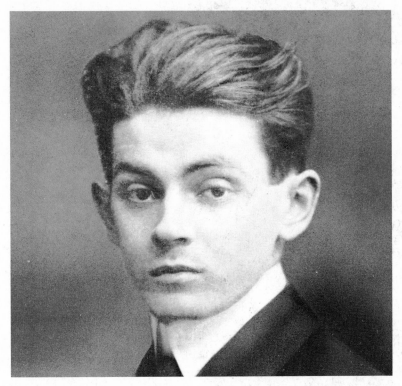

81b

82a

82b

83a

83b

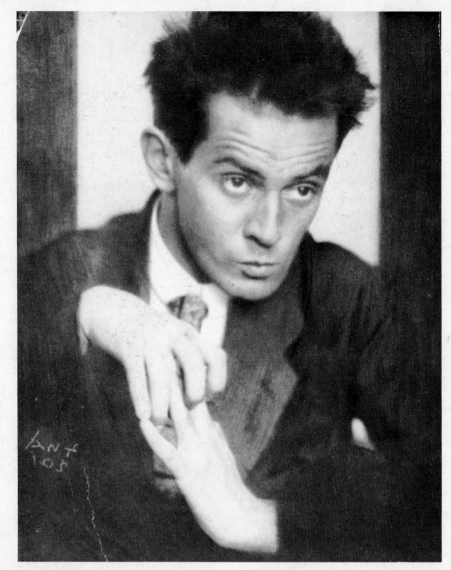

84a

84b

84c

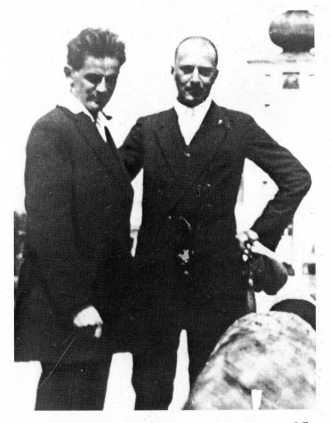

85a

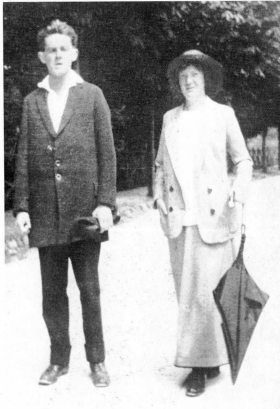

85b

85c

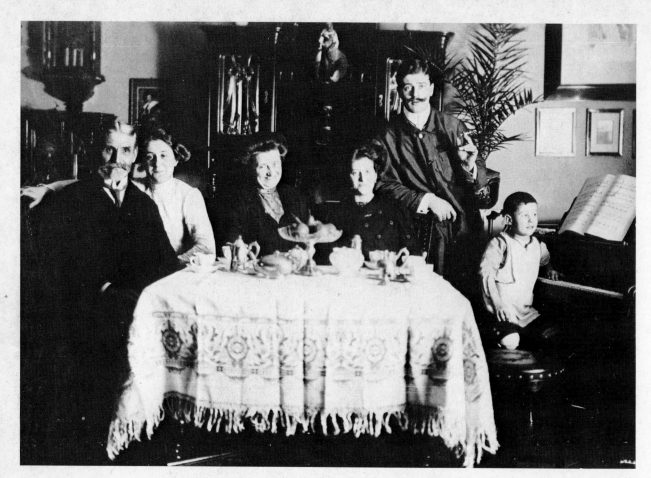

86a

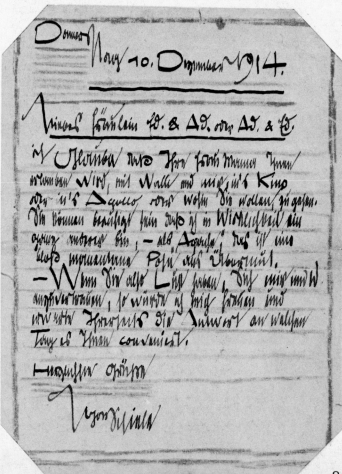

86b

87a

Lieber Egon,

Leider ist es mir heute nicht
möglich mit Dir zusammen zu sein.
Ich hab eine solch dicke Wange
d. ich mich unmöglich unter Leute
zeigen kann. Hoffentlich ist das
alles bis morgen weg. Soll ich
morgen mit Willi zu dir kommen?
Gib mir Antwort, aber so, d. es
niemand sieht, nämlich meine
Mama.

Ich hab dich ja so unendlich lieb!

Edith.

87b

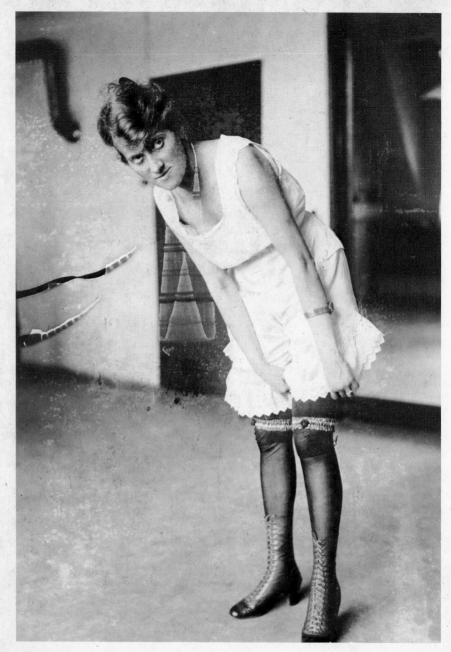

88a

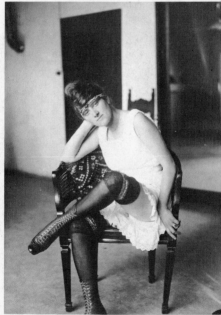

88b

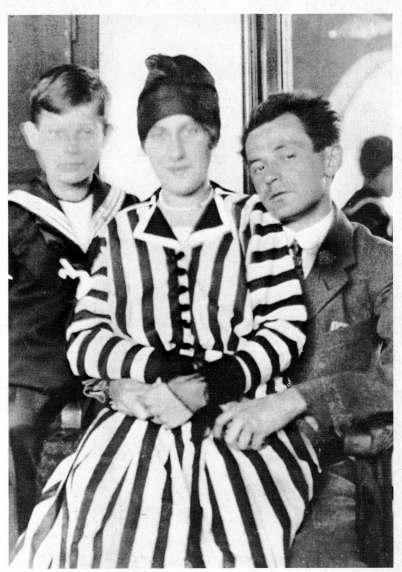

89a

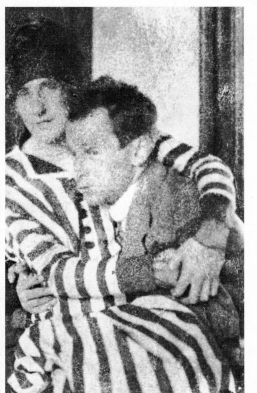

89b

Herr Johann und Frau Josefine Harms
geben sich die Ehre, die Vermählung ihrer Tochter
Edith
mit Herrn *Egon Schiele*, akad. Maler
welche am 17. Juni 1915 in der ev. Kirche stattge-
funden hat, anzuzeigen.

89c

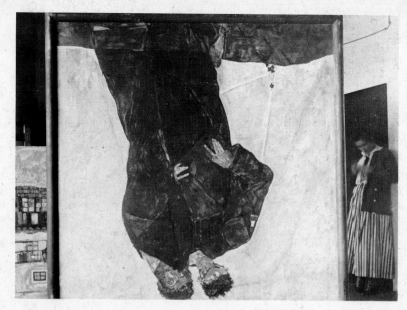

90a

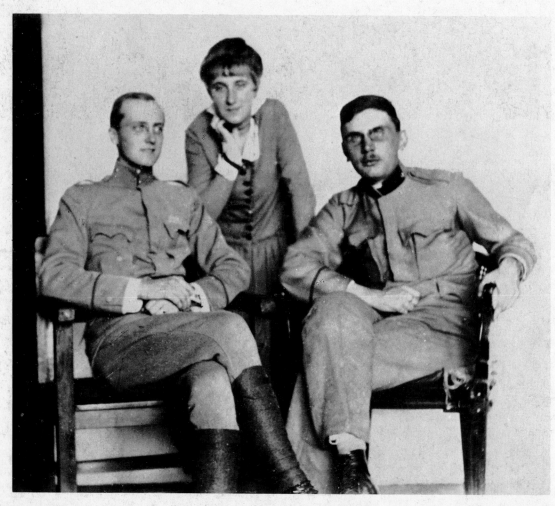

90b

91a

91b

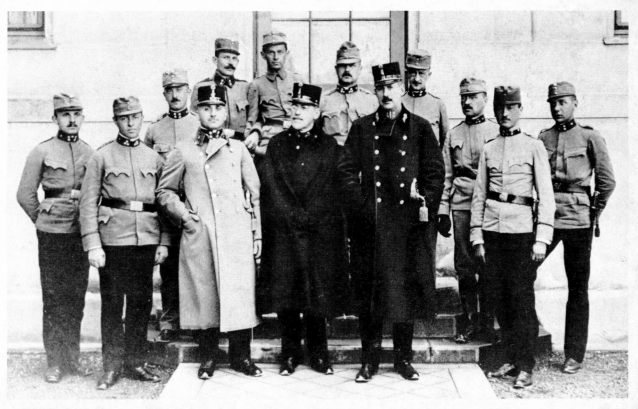

91c

92a

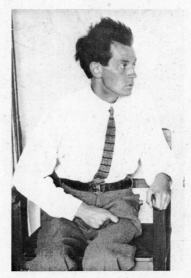

92b

Daß in unseren Tagen just ein Zeichner Schiele heißt, ist wohl kein Zufall. Er schielt noch nach Dingen, nach denen andere schon schauen. Zum Schielen aber ward eben just dieser Schiele eingesetzt..."

92c

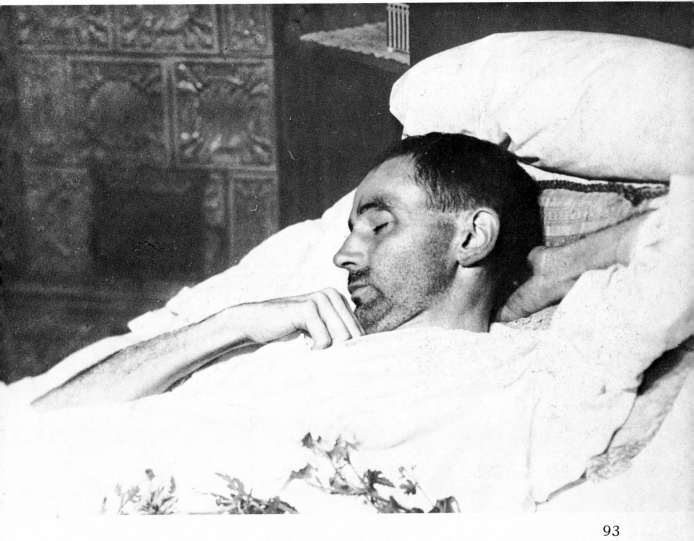

✝

Egon Schiele gibt im eigenen und im Namen seiner Schwiegermutter Frau Josefine Harms
sowie aller übrigen Verwandten die traurige Nachricht von dem Ableben seiner lieben Gattin

Edith Schiele

welche Montag den 28. Oktober 1918 um 8 Uhr früh im blühendsten Alter nach kurzen, schwerem Leiden
verschieden ist.
Das Leichenbegängnis findet am Donnerstag den 31. Oktober 1918 um 1/2 5 Uhr nachmittags von
der Kapelle des Ober-St. Peiter Friedhofes aus statt.

Wien, am 28. Oktober 1918.
XIII. Wattmanngasse 6

Leichenbestattung Franz Libsfan, 13. Ungerstraße 62. Druck von J. Peil.

94a

Marie Schiele gibt im eigenen und im Namen ihrer Töchter Gertrude und Melanie sowie aller
übrigen Verwandten die traurige Nachricht von dem Ableben ihres lieben Sohnes, bezw. Schwiegersohnes,
Bruders, Schwagers und Onkels, des Herrn

Egon Schiele
akademischer Maler

welcher Donnerstag den 31. Oktober 1918 um 1 Uhr nachts im blühendsten Alter nach kurzem, schwerem
Leiden verschieden ist.
Das Leichenbegängnis findet am Sonntag den 3. November 1918 um 1/4 3 Uhr nachmittags von
der Kapelle des Ober-St. Peiter Friedhofes aus statt.
Die heilige Messe wird Dienstag den 5. November 1918 um 1/2 9 Uhr vormittags in der Pfarrkirche
zum heiligen Veit in Ober-St. Veit zum Seelenheile des Verstorbenen gelesen.

Wien, am 31. Oktober 1918.
XIII. Hietzinger Hauptstraße 114

Leichenbestattung Franz Libsfan, 13. Ungerstraße 62. Druck von J. Peil.

94b

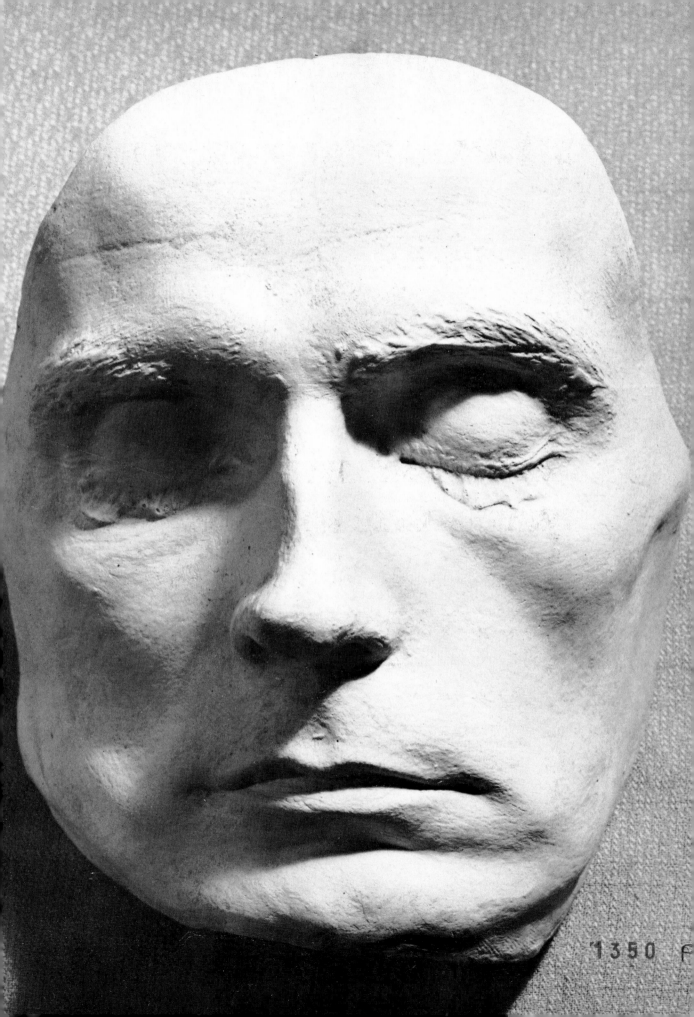